IMAGES
of America

WINDSOR

On the Cover: **Great Western Sugar Factory, 1903.** During the construction of the factory, workers installed equipment for turning sugar beets into granulated sugar. In this image, workers stand on scaffolding to install a crystallizer on the third floor of the factory. The crystallizer was used near the end of the sugar refining process; the heated juice of beets was fed into a pan, and sugar was crystallized from the solution. (Town of Windsor Museum, Permanent Collection.)

IMAGES of America
WINDSOR

Rachel D. Kline and the
Windsor-Severance Historical Society

Copyright © 2012 by Rachel D. Kline and the Windsor-Severance Historical Society
ISBN 978-0-7385-7615-2

Published by Arcadia Publishing
Charleston, South Carolina

Printed in the United States of America

Library of Congress Control Number: 2011926201

For all general information, please contact Arcadia Publishing:
Telephone 843-853-2070
Fax 843-853-0044
E-mail sales@arcadiapublishing.com
For customer service and orders:
Toll-Free 1-888-313-2665

Visit us on the Internet at www.arcadiapublishing.com

In loving memory of Linda Cumpsten,
a great friend and valuable member of the historical society,
whose vision it was to see this book written

Contents

Acknowledgments 6
Introduction 7
1. A Town Between: Early Years of Windsor 9
2. A Community Emerges: Leisure, Church, and School 29
3. Working the Fields: Agriculture in Windsor 51
4. Work Makes Life Sweet: Farming Sugar Beets 71
5. Sugar Beet Boom: The Great Western Sugar Factory 83
6. Mid-Century Town: Business, Community, and Recreation 99
7. New Industry: Kodak Colorado Division 119

Acknowledgments

Before moving to Windsor, I was invariably drawn to the town throughout my life—as a child who tagged along with my parents to stores on Main Street, and later, when I assisted the Town of Windsor with a downtown historical survey. Shortly after moving to Windsor, I went to a local coffee shop and wound up talking to Linda Cumpsten of the Windsor-Severance Historical Society about the town and its history. The historical society had been looking for some assistance with the creation of this book, and Linda enthusiastically brought me on board. I have since treasured every moment spent with the historical society.

Accordingly, I would first and foremost like to thank Gene Morey, Sue Buxmann, Marge Straube, and the late Linda Cumpsten for asking me to be part of this book and sharing Windsor's special history with me. They spent countless hours hunting down photographs and researching. They continually surprised me with their incredible knowledge of stories each photograph had to tell. Thanks also to members of the historical society and the Windsor community for sharing their photographs and stories.

I would like to sincerely thank the Town of Windsor for their support of this project and for sharing their images of Windsor. Special thanks to Elizabeth Handwerk Kurt, Carrie Knight, and Katie Bates for their time and assistance in selecting and researching photographs. Kurt went above and beyond to help with the creation of this book and spent many hours editing and selecting photographs.

I would also like to acknowledge staff members of various institutions for assistance in researching and providing photographs, including the staff at Colorado State University Archives and Special Collections, Fort Collins Local History Archive, Greeley History Museum, Colorado Historic Newspaper Collection, and the *Windsor Beacon*. CeCe Rautus from Eastman Kodak Colorado Division was a joy to work with and provided us with wonderful photographs and stories of Kodak. Great thanks also to Kris Walters at iPix Photograph Lab and Design in Windsor for restoring some wonderful photographs that would otherwise not have been included in this book.

My parents Ken and Jenny Bigham, parents-in-law William and Deborah Kline, and family deserve great thanks for all of their suggestions and encouragement during this long endeavor. Thanks also to Melissa Spaulding, Kaitlyn Scott, and Ashley Caruthers for their friendship and humoring me with my endless conversation of Windsor. Lastly, I wish to thank my husband, Christopher Kline, for his enduring support, endless humor, and helping me find the right words to say. *Zum Gott allein die Ehre sein.*

Photographs from the Town of Windsor Museum, Permanent Collection are denoted in the courtesy lines as TWM.

INTRODUCTION

Settled in the 1870s, the town of Windsor has encountered transition and struggled with an ever-changing identity. As a town between two county seats—Greeley and Fort Collins—that has navigated population swells and industry, Windsor has remained one of northern Colorado's lasting communities. As early as 1860, settlers claimed land south of the Windsor area, including Fred Whitney, James Pinkerton, and J.L. Hilton; Hilton built the "Half-Way House" in 1873 for travelers passing between Fort Collins and Greeley.

The principal catalyst for settlement and growth in Windsor was agriculture, with roots stretching back to New York City and the agricultural colony movement. Horace Greeley, the founder and editor of the *New York Tribune*, tasked agricultural editor Nathan Cook Meeker with exploring and observing the West in 1869. Impressed with the Colorado Territory's spectacular mountain vistas, friendly settlers, and immense opportunities, Meeker returned to New York and shared with readers his plan for establishing a colony in the territory. Meeker envisioned a utopian community: a colony based on temperance, education, agriculture, and "a good society." Just a few years earlier, in 1865, Arapaho and Cheyenne tribes ceded their claims to the land, opening the territory to settlement.

With the prospect of inexpensively purchasing or homesteading fertile tracts of land, a group of 737 hopeful individuals joined Meeker in forming a joint-stock colonization company called the Union Colony. By May 1870, settlers began arriving at their purchased acreage, located just west of the confluence of the Cache la Poudre and South Platte Rivers. They named the settlement Greeley in honor of Meeker's editor. To the northwest of Union Colony, the Fort Collins Agricultural Colony made use of an abandoned military compound and sought to create a town site with values similar to Meeker's. Families from both colonies dug ditches for irrigation, planted crops, and constructed houses, while others extended their livelihoods in all directions using the Homestead Act and other land-grant legislation. Eventually, colonists throughout the northern Colorado territory found opportunity in the fertile Cache la Poudre valley.

Edward Hollister, one of the original Union Colony settlers, purchased an 80-acre portion of land from the federal government. Hollister received his first land patent on June 10, 1872, and then homesteaded an additional 80 acres in 1878. When his wife, Charlotte, procured 80 acres in 1872 and 80 more in 1879, the Hollisters became the principal landowners between Greeley and Fort Collins, holding what would become almost all of Windsor south of Main Street.

While Hollister's holdings and the surrounding land stood directly between the two largest towns in the region, the area remained too remote for travelling and too dry for farming. The marshy river bottoms along the Cache la Poudre River provided for limited crops but could not support the farther-out grasslands. The Windsor town site did not become a reality until two of the West's most transformative enterprises—irrigation and railroads—were developed in the area. One of the earliest irrigation projects in northern Colorado was completed when the Lake Supply Ditch Company, comprised of Fort Collins and Windsor farmers, constructed its principal

reservoir: Lake Hollister. Just north of Hollister's homestead, the reservoir held the first priority to the Cache la Poudre River in the third water district. As the company expanded the reservoir over the years, Lake Hollister became known as Kern Reservoir and, later, Windsor Lake. Additional irrigation enabled Windsor to become an agricultural center.

While irrigation began the transformation of the area, it was the construction of the Greeley, Salt Lake & Pacific Railway (GSL&P) in 1882 that brought Windsor into full being. Passing through Hollister's property and following the south shore of the reservoir, the railway connected Greeley to Fort Collins in an almost-straight line. Realizing the advantages of a town between Greeley and Fort Collins with a picturesque lake and new access by railroad, Hollister and the Lake Supply Ditch Company hired H.P. Handy in 1882 to survey and plat a town site. Although Hollister died in 1888, it is believed that he named Windsor after his hometown of Windsor, New York. The town was officially incorporated on April 2, 1890.

The development of the town and the arrival of more settlers inspired residents with two different visions for Windsor. Many believed the agricultural opportunity and railroad opened up countless possibilities for commercial development; others saw the scenic lake, abundant wildlife, recreation, and easy transportation as the center of a leisurely retreat. As downtown businesses increased and the Great Western Sugar Factory opened a Windsor facility (in 1903), the town's fate became fixed as an agricultural and industrial processing center.

The opening of the Great Western Sugar Factory had a profound and lasting effect on Windsor, turning the burgeoning community into a boomtown. The population surged in Windsor with an increase of nearly 500 percent between 1900 and 1910. Downtown also grew exponentially with the construction of nearly half of all of its commercial buildings during the same time period.

Beyond its economic significance, the sugar beet industry permanently transformed Windsor's culture and society when the sugar beet companies employed hundreds of Germans from Russia. Having long grown sugar beets and developed an indefatigable work ethic, Germans from Russia provided inexpensive and dependable labor. Over the years, German-Russians became part of the core of Windsor's citizenry: they were prominent merchants, owned their own farms, and remained residents of the town. While Germans from Russia were the most populous early immigrants, several other ethnicities arrived in Windsor to work, including Hispanics (mostly Mexican), Japanese, Italians, and Scandinavians.

By 1930, the sugar beet boom had declined, though the industry remained a constant presence in the community until the 1970s. The town's population growth did not sustain the rate during the early sugar beet boom, but fluctuated between the 1930s and late 1960s, never exceeding 5,000 people. During this period, Windsor again transformed to accommodate new enterprises, such as the automobile, and changing economic needs. New highways and the designation of Main Street as both State Highways 257 and 392 brought new businesses and industry to Windsor, including a pickling station, hay mill, service stations, and car dealerships.

Despite its mid-century decline, Windsor once again became a bustling home to new industry when the Eastman Kodak Corporation constructed its western plant in Windsor in the late 1960s. With plenty of room for expansion, Kodak's 2,400-acre site included much of Hollister's former landholdings and the remains of the Great Western Sugar Factory. Kodak Colorado Division soon became Eastman Kodak's major manufacturing facility and one of the largest employers in northern Colorado, hiring most of its force from Windsor and breathing new life into the community.

In 1970, Mayor Wayne Miller aptly predicted that Windsor would change forever, requiring more roads, shopping, schools, and housing for a growing population. The double vision of Windsor as both a resort area and an industrial center resurfaced with the construction of two resort-like bedroom communities, Water Valley and Highland Meadows; the use of Windsor Lake for swimming, boating, and other recreational activities; and the recent introduction of a manufacturing facility owned by Vestas, an industry leader in wind energy. Windsor's ideal location between large Front Range communities remains essential as the growing bedroom community's population nears 20,000. Though Windsor has undergone several transitions, the town has proven its adaptability, and its residents—both longtime and new—remain the core of the community.

One

A Town Between
Early Years of Windsor

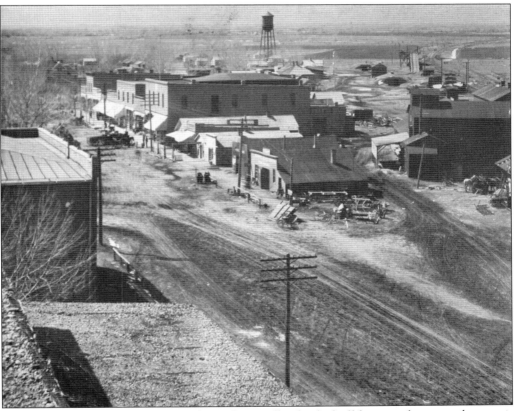

MAIN STREET, 1909. "It was just a swale, used as a wallow by the buffalo—merely a natural reservoir site which the settler had no more idea would one day become an important water storage basin than that the tiny settlement he was forming would someday be a town." During the transition from the 19th to the 20th century, the area Roy Ray (editor of the local newspaper, the *Poudre Valley*) spoke of flourished as a town with lively commerce, widespread irrigation, and plentiful opportunity. Main Street, stretching left of center, served as the major artery for business, with the railroad in the far right and Windsor Lake, to the northeast, just out of view on the right. The Rocky Mountains, to the west and seen in the background, provided a picturesque setting for a promising town. (TWM.)

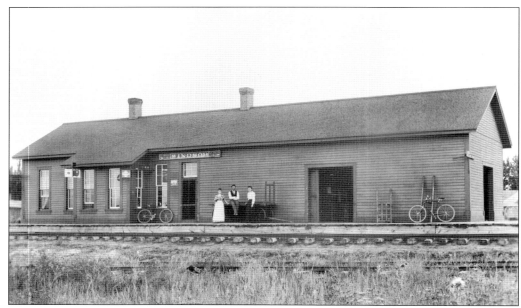

THE WINDSOR DEPOT, C. 1895. Irrigation made the area viable for farming, but the railroad turned Windsor into a town. Windsor's depot opened in 1882 as a combination depot for both freight and passengers. Depots served as central parts of communities for commerce, travel, and news and were symbols of the growing prosperity of a town. The depot agent is pictured in the center between the two women. (Collection of the Littleton Museum.)

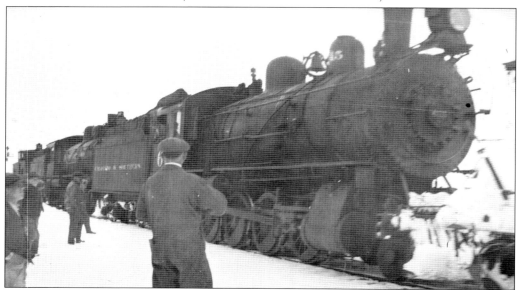

COLORADO & SOUTHERN RAILWAY, C. 1920. The railroad consolidated under the Union Pacific, Denver & Gulf, which operated it between 1890 and 1898. It was then sold to the Colorado & Southern (C&S) Railway. The Chicago, Burlington & Quincy Railroad took control in 1908, though the C&S continued operating the line. The Chicago, Burlington, & Quincy later became the Burlington Northern Santa Fe (BNSF), which currently maintains the railroad through Windsor. (TWM.)

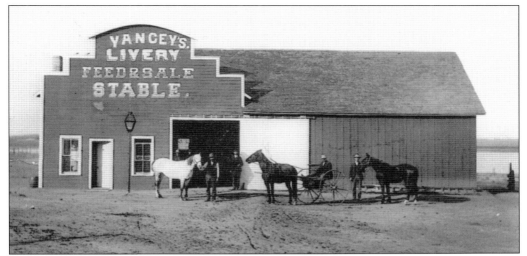

YANCEY'S LIVERY STABLE, C. 1890. In 1888, Charles Yancey constructed Windsor's first livery stable on the south side of Main Street's 400 block, close to the depot. Yancey, originally from Virginia with a diverse background in trades, became one of Windsor's most prominent downtown investors during the sugar beet boom, constructing several business blocks on Main Street. (*Windsor Beacon*.)

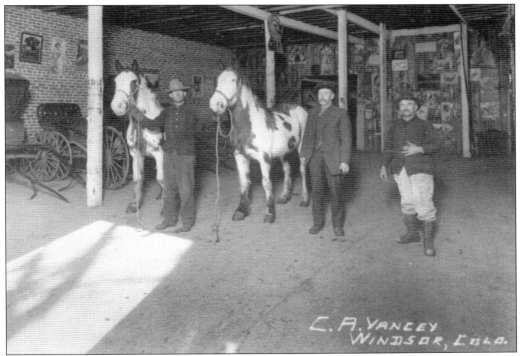

INTERIOR OF LIVERY STABLE, C. 1890. Starting out with only a single horse, Charles Yancey soon provided travelers and residents with a stable of 35 horses. Yancey (center, between two unidentified men) later increased his business to include horse and mule trading, a feed barn, and a harness shop. In 1917, he boasted of selling more harnesses than any other business in Fort Collins or Greeley. (John Brunner.)

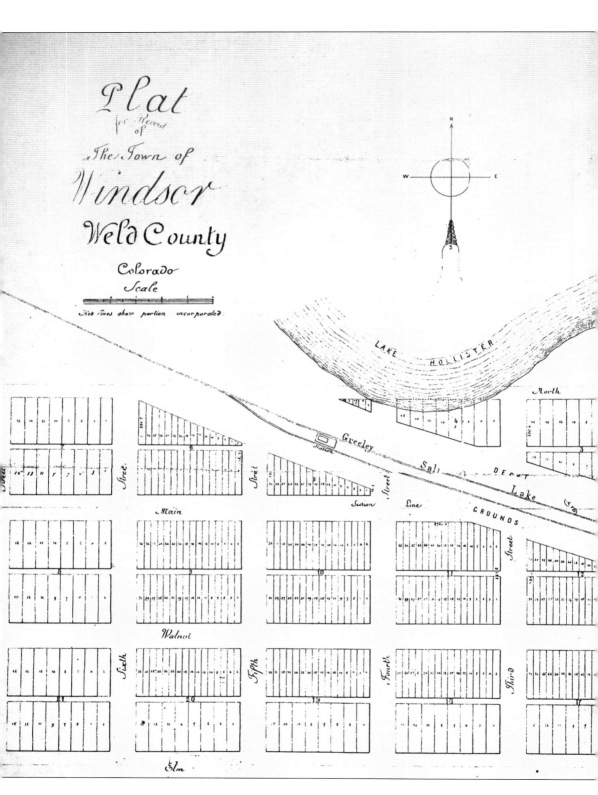

PLAT OF THE TOWN OF WINDSOR, 1882. H.P. Handy, hired by Edward Hollister and the Lake Supply Ditch Company, completed the survey and plat of the Windsor town site on November 20, 1882. Rather than the traditional alignment of Main Street with the railroad, Handy positioned Main Street just south of Windsor Lake, running east to west against the diagonally running railroad. This unusual alignment was most likely a savvy business maneuver. Still bound by Union Colony's temperance rules, Hollister could develop a commercial district that upheld the colony's values on his land south of Main Street. Meanwhile, the Lake Supply Ditch Company, which owned the land north of Main Street, could attract businesses to the lots near the lake without restriction, including hotels, which generally sold liquor. (Weld County Clerk and Recorder.)

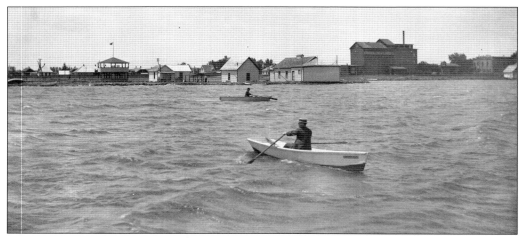

WINDSOR AS RESORT, C. 1900. Above, Windsor's scenic lake, teeming with wildlife, convinced many early settlers that Windsor should remain undeveloped as a lakeside resort. In the early 1880s, hunter Robert Harris constructed Windsor's first hotel, Hotel de Harris, and ran advertisements (below) in the *Greeley Tribune* touting Windsor as the ideal getaway. Although Harris closed the hotel in 1907, throughout the early 20th century, other entrepreneurs sought to revive the resort idea by stocking the lake with fish, constructing athletic fields, a dance pavilion, and an opera house, and bringing in the Gentry Brothers Circus. While the resort idea never entirely vanished, Windsor became more of a commercial center. As Roy Ray put it: "It is time for Windsor . . . to get to work." (Above, TWM; below, Colorado Historic Newspaper Collection.)

HOTEL DE HARRIS,

Windsor is a

FAMOUS RESORT.

The Lakes are well stocked with Fish and Ducks for lovers of

ROD AND GUN.

Landlord Harris has a State reputation as an expert in both

HUNTING & FISHING

And his Table and Beds are a joy.

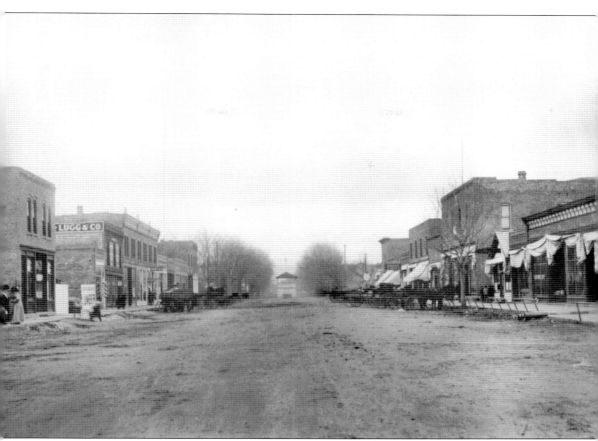

MAIN STREET, 1901. Hershel D. Seckner constructed the first building on Main Street, a general store that opened in December 1882. The shop also housed the town's first post office box. Seckner's small, wood-frame building on the north side of Main is pictured third from the right. The public water trough for horses, located at the intersection of Main and Fifth Streets, is in the central background. (Colorado State University.)

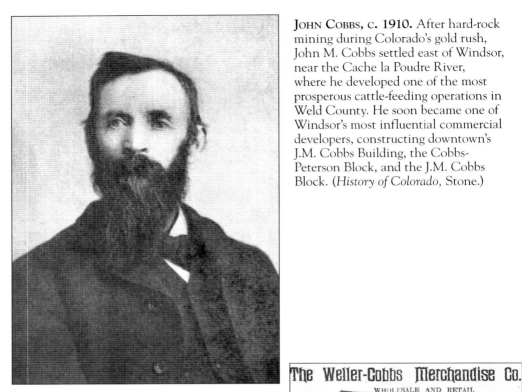

JOHN COBBS, C. 1910. After hard-rock mining during Colorado's gold rush, John M. Cobbs settled east of Windsor, near the Cache la Poudre River, where he developed one of the most prosperous cattle-feeding operations in Weld County. He soon became one of Windsor's most influential commercial developers, constructing downtown's J.M. Cobbs Building, the Cobbs-Peterson Block, and the J.M. Cobbs Block. (*History of Colorado*, Stone.)

WINDSOR BUSINESS DIRECTORY, 1893. With partner Walter Woodward, John Cobbs opened a small business in 1882 to sell hay, grain, produce, coal, and farming equipment. The business soon evolved into a general merchandise store and commissary. As Cobbs's various partners left, the firm reorganized until Frank L. Weller joined the firm, forming The Weller-Cobbs Merchandise Company. (Colorado Historic Newspaper Collection.)

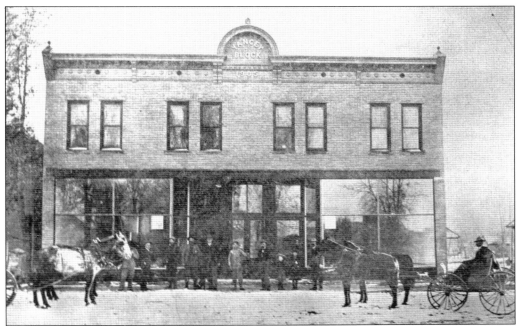

YANCEY BLOCK, 1905. Charles Yancey also constructed several business blocks on the 400 and 500 blocks of Main Street. In 1905, Yancey constructed the largest and most impressive building in Windsor at the time—the Yancey Block—at 517–519 Main Street. One of the prominent leaders of Windsor, Yancey served as mayor between 1908 and 1911. (*Windsor Beacon.*)

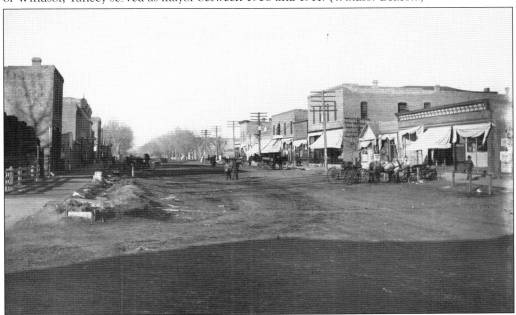

MAIN STREET, 1909. In 1908, the town board approved an ordinance to bring the Northern Light and Power Company to Windsor. The first electric lights were illuminated on February 3, 1909, and in celebration, the town held a gala event and evening parade under the lights on Main Street. (TWM.)

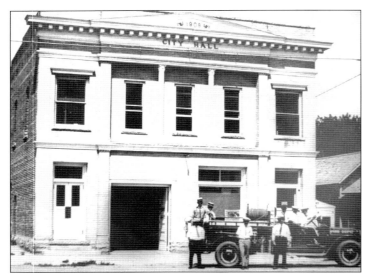

Town Hall, c. 1916. Charles Yancey oversaw construction of town hall in 1909, boasting that it was the "grandest stone ever laid in Windsor." The original floor plan featured offices, a vault, a jail, police and fire departments, and sleeping quarters. The volunteer fire department, posing in front, was organized in 1902 and acquired its first motorized fire truck in 1916, although the motor was not too dependable. (TWM.)

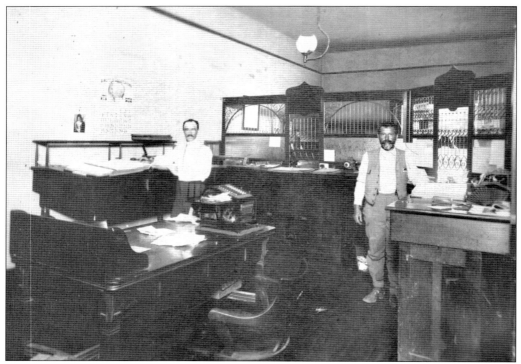

Windsor Bank, 1904. Following the construction of the sugar factory (in 1903), Windsor opened the Bank of Northern Colorado with capital stock of $30,000. Located on the corner of Main and Fifth Streets, the bank had one cashier, C.S. Harley (right), and several stockholders, including Lewis Kern (left). In 1919, a two-story structure with spacious parlors, offices, accounting quarters, and secure vaults replaced the original bank. (TWM.)

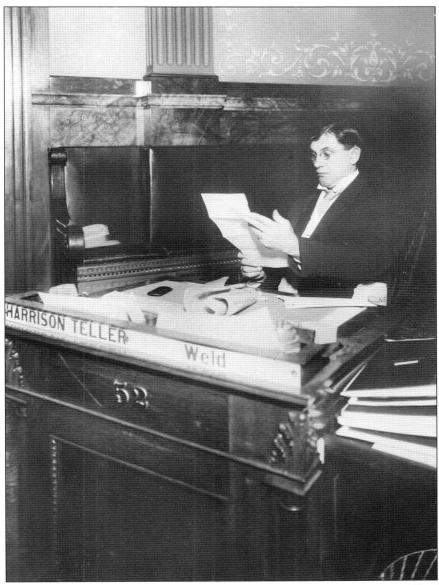

HARRISON TELLER, C. 1910. Son of Windsor postmaster Lewis Teller, Harrison Teller became a prominent Windsor businessman when he purchased Seckner's general store. Teller later partnered with Otis Hill to form the Hill-Teller Mercantile Company and constructed a grain elevator and potato warehouse. In 1898, the Hill-Teller Mercantile Company moved from its original location to the two-story building next door at 414 Main Street. In January 1890, Teller and Hill reorganized to form the Windsor Mercantile Company. The business flourished on the first floor of its new location, while the Independent Order of Odd Fellows occupied the upstairs. "Where Windsor shops with confidence" became the motto of "the Merc," which sold hardware, dry goods, groceries, and appliances. The Mercantile was a staple of downtown business until it closed in 1959. Teller served as a bank stockholder and was president from 1909 until his death in 1925. In 1924, he briefly served as postmaster but left the post due to ill health and a dislike of indoor confinement. (TWM.)

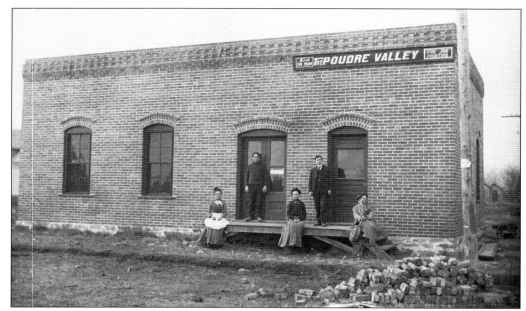

THE *POUDRE VALLEY*, C. 1900. News was printed as early as 1886 in Windsor and formally established in 1898 as the *Windsor Leader*. In 1901, Roy Ray purchased the local printing plant and renamed the newspaper the *Poudre Valley*, locally known as "the P.V." With a reputation as a chatty friend with a pungent editorial style, Ray produced one of the most widely read and quoted small-town newspapers in Colorado. (TWM.)

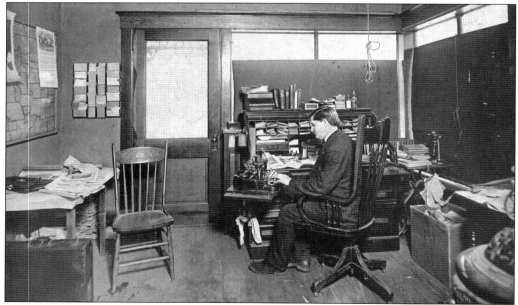

ROY RAY, C. 1900. Newspaper editor Roy Ray was one of Windsor's greatest champions and civic leaders for 41 years. With his wife, Ethel Dumas, Ray published the *Poudre Valley* until his death in 1942. Ray also served as a town clerk, town board member, mayor, district chairman of the USO, grand master of the Odd Fellows, and was twice elected to the Colorado House of Representatives. (TWM.)

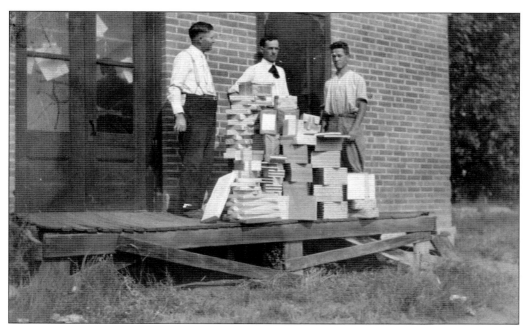

PRINTING ORDERS, 1917. Published weekly, the *Poudre Valley* began as a family affair. Ray's wife, two sons, daughter, and sister helped with editing, reporting, setting type, and printing. After Ray's death, his wife, Ethel, continued publishing the paper until 1947; the last issue was printed on March 27, 1947. The paper was then sold, and the name was changed to the *Windsor Beacon*. (TWM.)

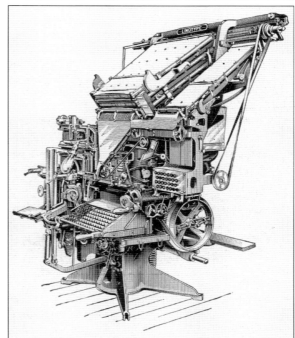

THE P.V. PRINTERY, 1917. In August 1910, Roy Ray installed a junior Linotype—the first Linotype used in Weld County (outside of Greeley)—to print his paper. The paper outgrew the junior model in six years, replacing it with the Linotype Model 14 in 1916. The Model 14 featured three magazines, an auxiliary magazine, and 540 different characters. (1917 *Ocowasin* yearbook.)

THIS IS THE most versatile Linotype in Northern Colorado, and enables this office to handle a great variety of printing at a moderate cost. Let us do yours. This "Annual" was printed from cover to cover in the P. V. Printery Office.

The P.V. Printery

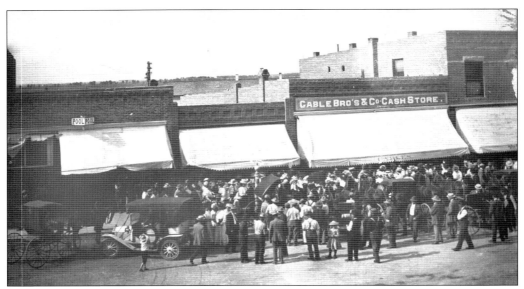

CABLE BROTHERS MERCHANDISE COMPANY, 1917. As Windsor's commercial district matured, businessmen rebuilt many of the early wood-frame storefronts with brick. New businesses emerged and expanded, such as the Cable Brothers Merchandise Company, which replaced Windsor's first bowling alley and pool hall in 1921. In the 1930s, this general store once again became the Windsor Bowling Alley, boasting three alleys and duckpin bowling. (TWM.)

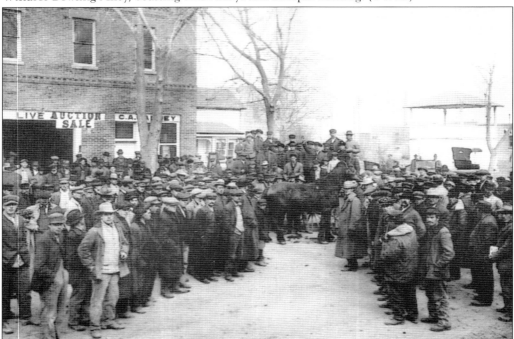

YANCEY'S AUCTION, C. 1910. At Charles A. Yancey's annual auction, farmers purchased draft horses to help with labor around the farm. Auctioneers and farmers sought to match teams of horses that would work well together. The auction pictured was held in front of Yancey's newly constructed brick livery building at 512 Main Street; Yancey's home is in the background. (John Brunner.)

OSTERHOUT LUMBER COMPANY, C. 1920. George E. Osterhout (pictured) was a Windsor pioneer and businessman. He helped petition for the town's incorporation and operated the lumberyard located at 411 Main Street. He also helped form the Windsor Library Association and served as town trustee. A celebrated botanist, Osterhout classified over 20,000 plants and was a known authority on botany in the West. (TWM.)

WINDSOR HARDWARE AND SUPPLY COMPANY, 1920. In 1916, brothers Carl and Walter Besel purchased a small hardware store in town and renamed it the Windsor Hardware and Supply Company. When Carl was drafted into the Army in 1917, Walter ran the store in his absence. The Besels sold hardware and provided plumbing, heating, and electric wiring services until the late 1960s when the store closed. (TWM.)

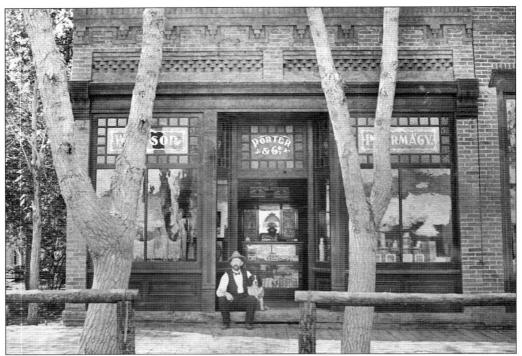

Dr. Porter's Pharmacy, c. 1901. Dr. Frank R. Porter, pictured here outside his drugstore, was one of Windsor's first doctors. The Windsor Pharmacy caught fire in 1901 and burned to the ground, damaging both its neighbors: Bert Cloud's Barbershop and the Alamo Hotel. Porter reconstructed the one-story building at its original location at 429 Main Street in 1901. (TWM.)

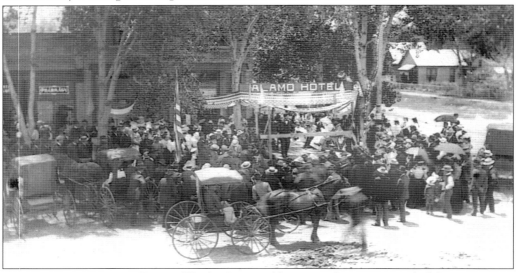

Alamo Hotel, c. 1901. Due to Windsor's central location, the town was ideal for transacting business during the day, but it was not necessarily a place to stay overnight. Travelers often found lodging in the large and sophisticated hostelries of Greeley and Fort Collins. The Alamo Hotel, at 431 Main Street, optimistically sought to lure this clientele but closed in November 1903. (TWM.)

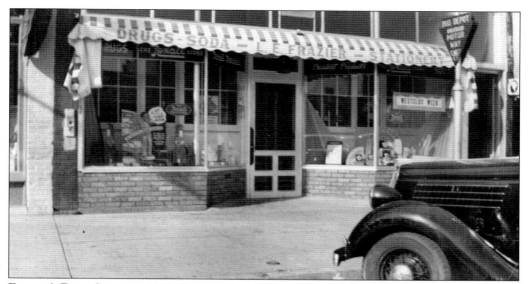

FRAZIER'S DRUG STORE, C. 1930. Operated by L.E. Frazier, Frazier's Rexall Store served as "a modern, progressive drugstore" that became one of the oldest operating businesses in Windsor, second only to the Windsor Mercantile store. Located at 420 Main Street, Frazier's filled prescriptions, sold stationary, business, and school supplies, and offered a fountain service. (David Frazier.)

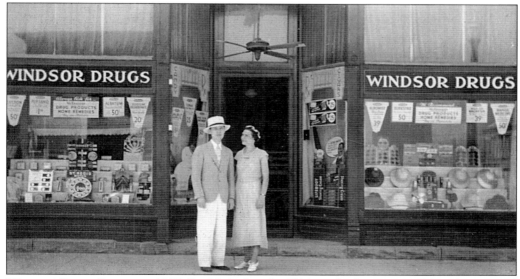

WINDSOR DRUG COMPANY, 1937. Established in the 1920s at the former site of the Alamo Hotel (431 Main Street), the Windsor Drug Company was run by Leonard and Grace Roberts (pictured) from 1934 to 1943. A registered pharmacist, Leonard offered prescriptions, liquors, and a fountain service. After the Roberts sold the shop, it became known as Terry's Corner Drug Store and later as Lieser's Corner Drug Store. (Diane Gruner.)

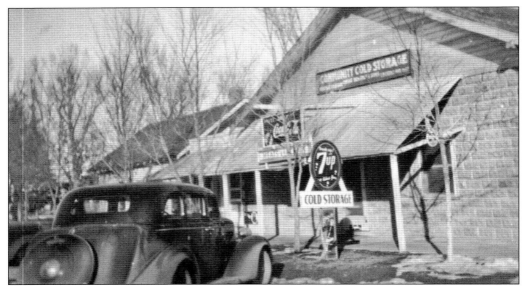

COMMUNITY COLD STORAGE, C. 1930. Off of Third and Walnut Streets, Chris Schmidt and his sons ran the neighborhood German-speaking grocery and butcher shop. Patrons often rented frozen-food lockers at the shop to store personal food items, as no one had a freezer in their home. Children attending the nearby Park School often went to the shop during lunch recess to buy candy. (Delores Lutz.)

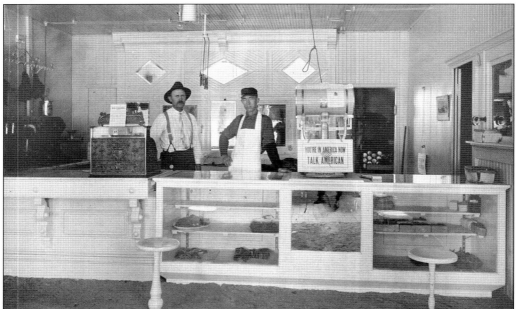

WINDSOR MEAT MARKET, C. 1910. Following the influx of German-Russians after the sugar factory opened, many faced discrimination. Some businesses posted signs such as the one in this image, which reads: "You're in America now—talk American." In response, the German-Russian community opened their own stores specializing in German-Russian goods and services, including cuisine. These diverse needs allowed Windsor to support seven grocery stores, even when the town's population shrunk to about 1,500 by 1940. (TWM.)

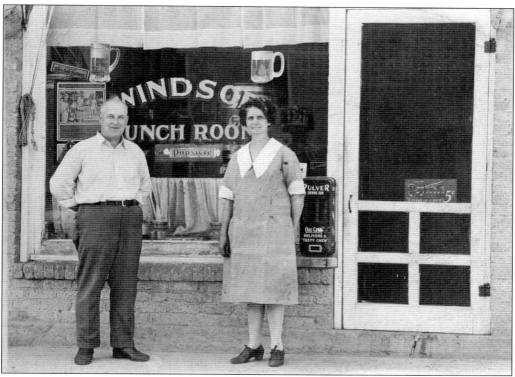

WINDSOR LUNCH ROOM, C. 1927. Above, Roy and Mary Woods stand in front of their Windsor Lunch Room, located next to the Windsor Theater. The Woods owned several restaurants in town, including the Drop Inn Cafe and Woods Coffee Shop. Below, Mary Woods and her daughter, Edna Dean Fortier, stand behind the counter of the Windsor Lunch Room. (TWM.)

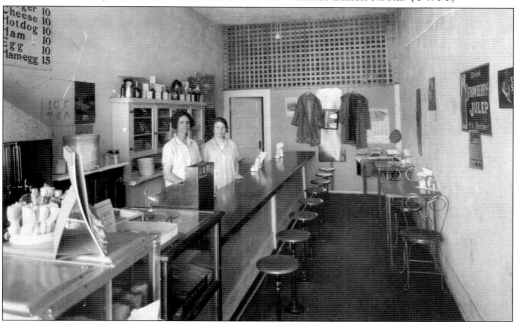

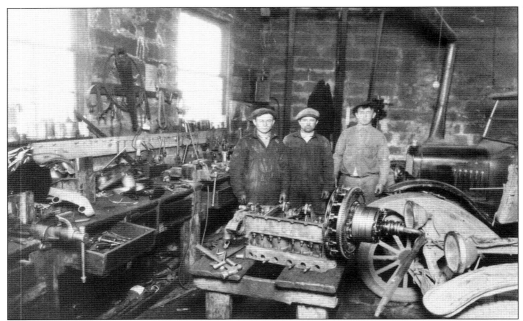

WINDSOR REPAIR SHOP, 1920. Located at 520 Main Street, the Windsor Repair Shop provided automobile and tractor repair. Pictured here from left to right are Henry "Shorty" Reichel, Jake "Speed" Weinmeister, and Pete Clouse. (John Brunner.)

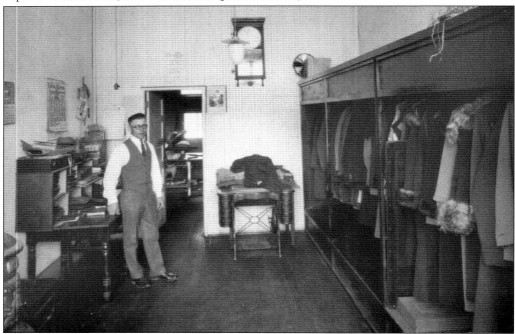

ALEX LORENZ, 1927. Born in Oberdorf, Russia, Lorenz immigrated to the United States in 1913. He had a long career in Windsor, stretching from 1915 to 1982. He ran a tailor and dry-cleaning shop, where he also sold men's custom-fitted suits. Lorenz is pictured in the main part of the store, near the dry cleaning. (TWM.)

Two
A COMMUNITY EMERGES
LEISURE, CHURCH, AND SCHOOL

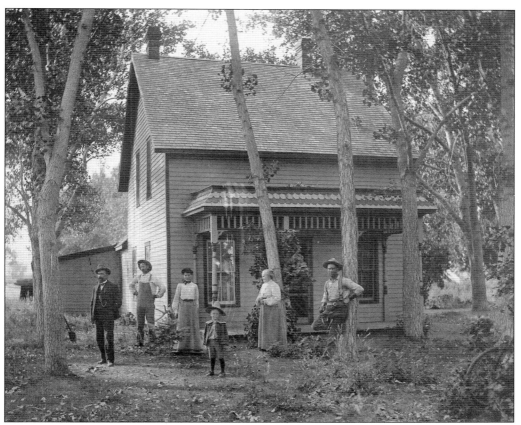

WILLIAM H. PETERSON HOME, 1905. While business thrived on Main Street, the Windsor community flourished around it. As those like prominent businessman William H. Peterson helped establish a lively commercial center, they also built lives at home. Peterson set up a homestead five miles northwest of town in 1872. Pictured here are, from left to right, William H. Peterson, Fred Crane, Jessie Peterson Harding, Harry Harding, Louisa Peterson, and Charles Peterson. (TWM.)

WINDSOR IMPROVEMENT CLUB, 1905. As the turn of the century ushered in a progressive era, Windsorites sought to better the community with civic buildings and programs. Through social organizations, women became prominent advocates for progressive change in Windsor. Established in 1899, the Improvement Club sought to increase and spread knowledge throughout Windsor; the club frequently met to discuss community issues and development. Notably, the group championed the creation of Windsor's library. (TWM.)

BACHELOR'S HALL, c. 1890. The Bachelor's Hall provided unmarried men and widowers of Windsor with a place to congregate and socialize. Several other fraternal and coed organizations also sprang up around town, including the Freemasons, the Order of the Eastern Star, the Independent Order of Odd Fellows, the American Legion, the Windsor Garden Club, and the Windsor Lions Club. (TWM.)

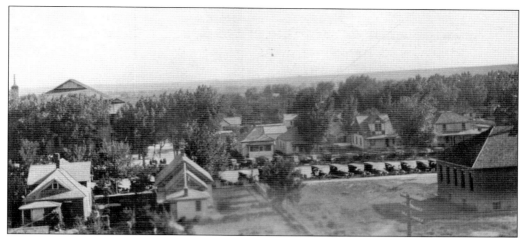

WALNUT STREET, C. 1910. Most of Windsor's community expanded south of Main Street. Taken from the top of the Windsor Elevator, this view of Walnut Street provides a snapshot of community growth. On the far right in the foreground is Bethel Lutheran Church, which once housed the high school and, later, the library. The high school at the time, Park School, is on the far left across the street. (Lois Hettinger.)

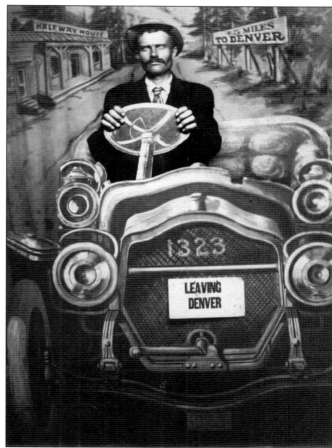

THEODORE SORENSON, 1907. A prominent community member, Sorenson arrived in the United States in 1902. He came to Windsor via Denver in 1907 and found it to be an ideal place to live. He was on Windsor's town board for 14 years and served two terms as mayor. Known as "Theo," he also raised sheep and bees on his farm with his wife, Gertrude. (TWM.)

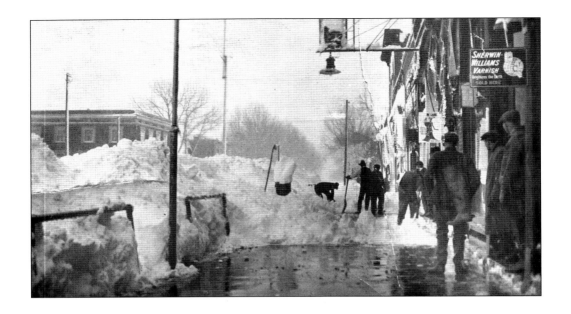

BLIZZARD, 1920. Windsorites spent many days shoveling out after a large snowstorm came through town in April 1920. The *Poudre Valley* noted that several feet of snow created drifts on Main Street in fantastic fashion as the wind whipped around the buildings. Fortunately, the extremely wet snow stayed in the fields, benefitting the farmers. By April 22, six feet of snow had been reported on Main Street roofs, with locals worrying about whether the roofs could hold the weight. Below, two locomotives with snowplows cleared the railroad tracks, which had drifts up to seven feet. (TWM.)

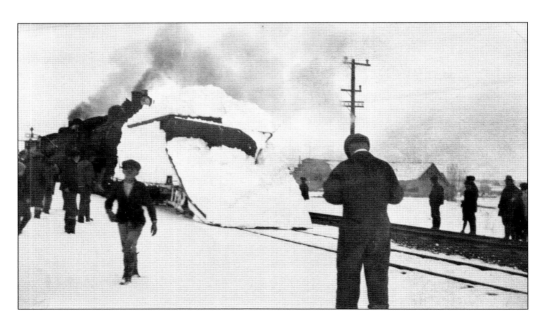

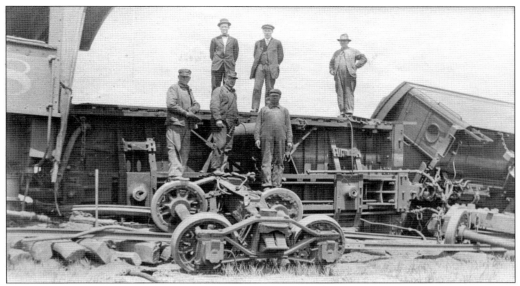

TRAIN WRECK, C. 1920. One of many wrecks along the Windsor line, this happened behind the Windsor Mercantile. The passing train was said to have been extremely old, resulting in its derailment. George Teller, then owner of the Windsor Mercantile, and his family were the first to provide help on the scene. Here, Teller stands in the center atop the derailed car. (TWM.)

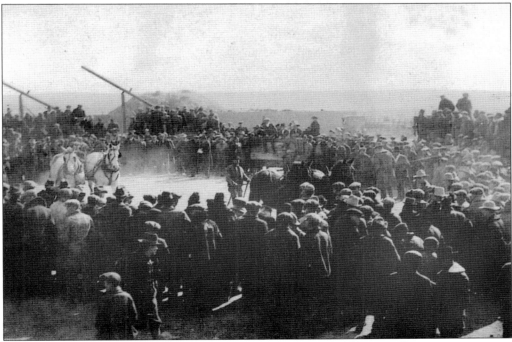

HORSE PULLING, C. 1900. For amusement, Windsorites often held horse-pulling competitions to see how much weight each team could pull. It was a popular weekend activity that later gave way to tractor-pulling competitions. (Linda Cherrington.)

INA RAINS, C. 1930. Known as Windsor's songbird, Rains was an internationally famous opera singer. Born and raised in Windsor, she attended the Lamont School of Music in Denver in 1923, continuing her training in New York City. Before leaving for Europe to expand her schooling and career, Rains performed a farewell concert at the Denver City Auditorium, where more than 300 Windsorites attended. In Europe, Rains gained fame in opera under the stage name Ina Souez. She appeared in Rome, Paris, Vienna, Copenhagen, Stockholm, and London and was the highest-paid soprano with the BBC. In 1938, she returned to Windsor and thrilled the town by performing a concert at the Methodist church for a library benefit. She returned to the United States for good when World War II began, teaching voice lessons in Hollywood while performing with various orchestras. (TWM.)

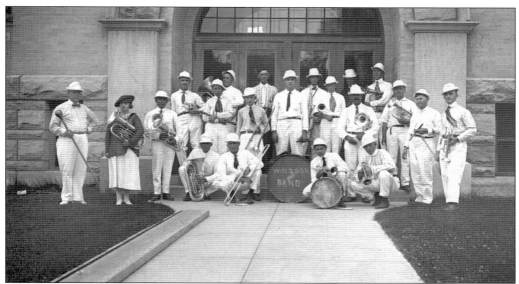

WINDSOR BAND, 1918. The Windsor Band gained fame in 1899 when it took first place at the Festival of Mountain and Plain in Denver. The band played at local and regional celebrations, including Cheyenne Frontier Days, Greeley's Fourth of July events, and at the Windsor Park bandstand and the Windsor Theater. Roy Ray (far left) managed the band for several years. (Greeley History Museum.)

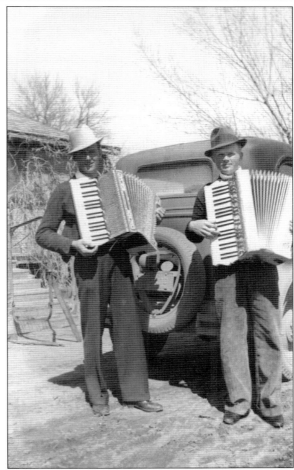

WINDSOR ACCORDIONS, 1937. Playing and listening to music was a weekend afternoon tradition. Paul Fritzler (left) and Robert Haas are pictured with their accordions—one of the more popular instruments among Windsorites. Another popular tradition was the Dutch Hop, a dance accompanied by a dulcimer, trombone, drums, and accordion. Windsorites held Dutch Hops for weddings, anniversaries, and almost every Saturday night at the American Legion. (Paul Fritzler.)

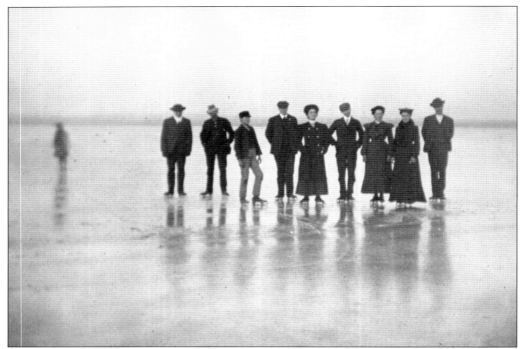

ICE-SKATING ON WINDSOR LAKE, 1905. Although Windsor did not become a lakeside resort town, Windsor Lake still drew locals and passersby for year-round recreation. Fishing, boating, and swimming were popular activities on the lake during warm weather, while ice-skating provided winter entertainment. (TWM.)

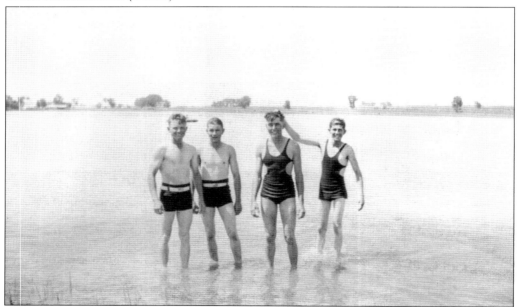

SWIMMING AT NEFF LAKE, 1935. In addition to Windsor Lake, locals also made use of Neff Lake, located six miles east of town, for irrigation and recreation. Pictured here from left to right are Alex Haas, Henry Brunner, Carl Felte, and Gerhart Brunner. (Paul Fritzler.)

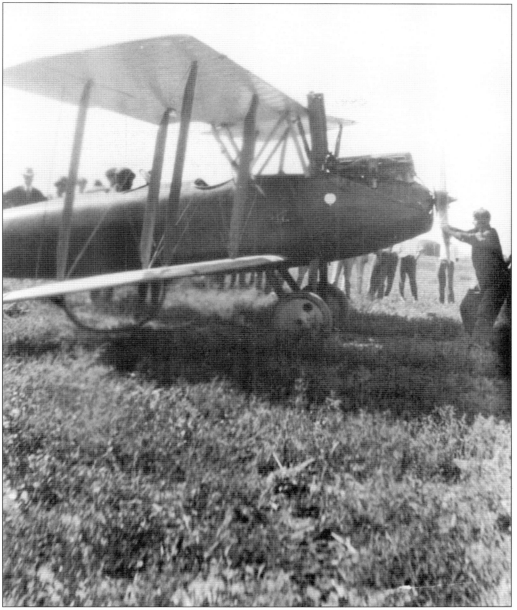

BARNSTORMING WINDSOR. In the 1920s, pilots spent summers barnstorming across the nation to entertain locals with new aviation techniques, gain flying experience, and make a profit. In the summer of 1924, a barnstormer landed on Carl Breniman's farm, selling airplane flights to Windsor locals and taking Breniman up in the plane for free for allowing him to land. (Windsor-Severance Historical Society.)

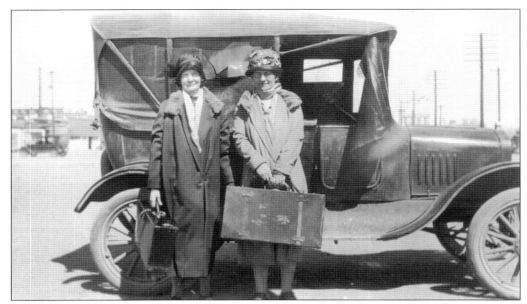

GOING ON HOLIDAY, C. 1910. The introduction of the internal combustion engine in the late 19th century revolutionized transportation and the American landscape. At first a luxury item, the automobile soon became available to the masses and literally changed the way people moved. With such autonomy, many began traveling out of state for leisure, such as Hilda Swanson (right) and her unidentified friend, pictured next to their Ford Model T. (Wilma Swanson.)

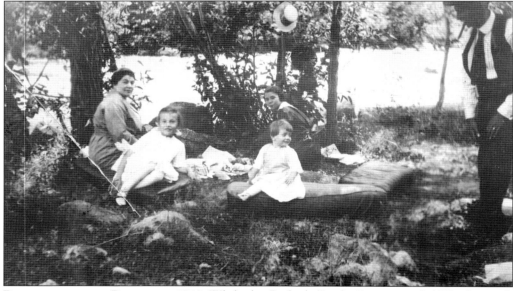

PICNICKING ON THE POUDRE, C. 1910. While the Cache la Poudre River provided Windsor with vital water for irrigation, the river also served as a recreational area. On leisurely afternoons, Windsorites picnicked along the river under its shady trees. Pictured here from left to right are Lovella Teller, Anna Caroline, Helen Covey, Dorothy Shreve, and Tom Shreve. (TWM.)

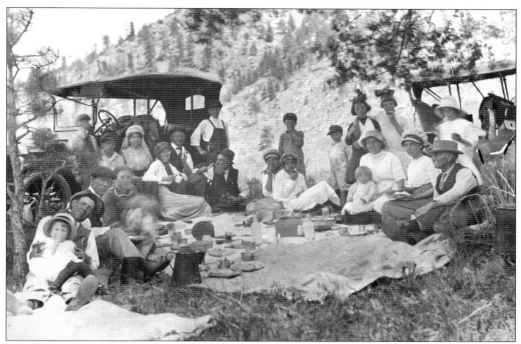

PICNICKING IN THE FOOTHILLS, C. 1910. Windsor families often made the short trip west for recreation in the foothills and mountains. The growing availability of the automobile made the journey easier and allowed families to visit more frequently. Pictured here are members of the Challgren, Frye, Koehler, Hanna, and Walker families. (TWM.)

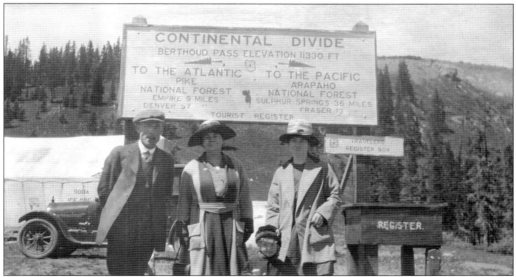

DRIVING THE DIVIDE, C. 1910. While the automobile allowed Windsor families to travel farther, it also took them to new heights. Pictured here from left to right are George and Lovella Teller and Katherine and Margaret Walker visiting the Continental Divide on Berthoud Pass at an elevation over 11,300 feet. Berthoud Pass, west of Denver, traversed winding switchbacks and steep grades. (TWM.)

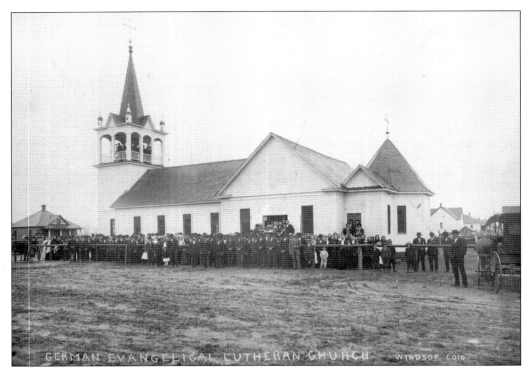

St. John's Evangelical Lutheran Church, c. 1910. The first congregations established in Windsor included the First Methodist Episcopal (1885), Christian Church of Windsor (1898), St. John's Evangelical Lutheran (1903), German Congregational (1904), St. Alban's Episcopal (1910), Zion Evangelical Lutheran (1914), and Windsor Assembly of God (1937). German-Russian immigrants attended St. John's, where services were given in German. (TWM.)

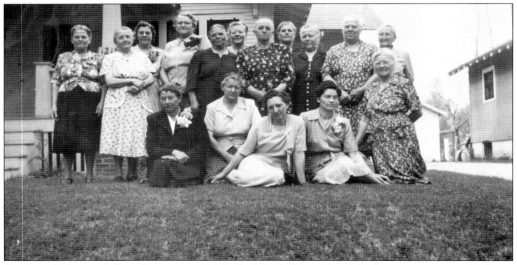

St. John's Ladies' Aid Group, c. 1935. St. John's Evangelical Lutheran maintained a large and active ladies' aid group, with 39 members by 1940. Members of the German community in Windsor supported one another in many ways, participating in this group and attending services together. (Paul Fritzler.)

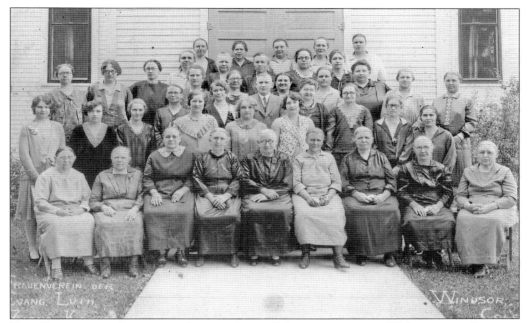

ZION EVANGELICAL LUTHERAN CHURCH LADIES' SOCIETY, C. 1914. With so many German-Russian immigrants in Windsor, a second German-speaking congregation organized as the Zion Evangelical Lutheran Church. Unlike most local congregations that met in schools or homes before constructing a church, members of Zion Evangelical Lutheran Church moved into the new church shortly after they organized in 1914. (Sue Buxmann.)

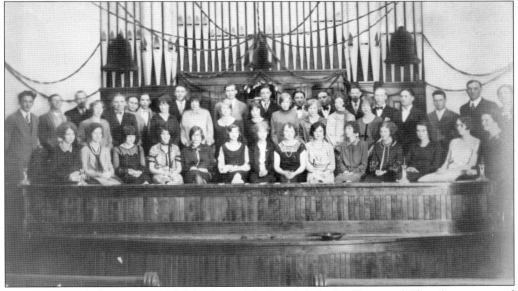

YOUNG PEOPLE'S CHOIR, C. 1925. Members of the First Methodist Episcopal Church constructed Windsor's first denominational church in 1885; the church soon became a social center of the community. Soon after, a ladies' aid group and a missionary society formed to support church activities. In 1914, the church was razed and a second building was constructed in its place. The choir is pictured in the newer church with director Josephine Kern. (TWM.)

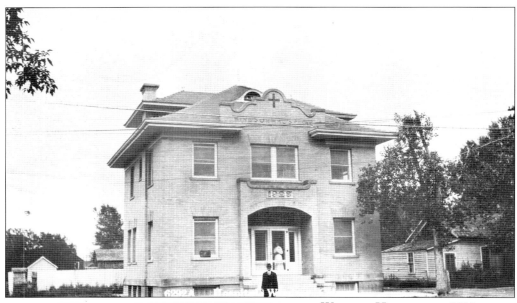

WINDSOR HOSPITAL, C. 1910. Between 1908 and 1909, Doctors Thomas Gormly and E.I. Raymond built Windsor's first hospital for $12,000. The building contained offices on the main floor and operating rooms, sterilization rooms, a ward, and five private patient rooms on the second and third floors. A dumbwaiter transported food and supplies between floors. On October 3, 1909, Arthur Wright was the first child born at the Windsor hospital. (Lydia Hettinger.)

HOSPITAL ADVERTISEMENT, 1917. Dr. L.E. Bartz opened Windsor's second hospital in 1916, naming it in memory of his child who died in infancy. The building had 15 beds, an operating room, X-ray equipment, and a diagnostic laboratory. Over the years, Windsor's two hospitals housed the offices of Doctors Gormly, Haskell, Nelson, Payne, Hanshew, and Sabin. Both hospitals closed in the 1940s, although the doctors continued their practices. (The Windsor-Severance Historical Society.)

Dr. Clarence Sabin, c. 1960. After arriving in Windsor in 1932, Sabin became one of the longest-serving and most beloved doctors in Windsor. He often accepted food as payment and eased children's fears during examinations by making them laugh with funny noises. During his career, he delivered 1,035 babies and kept photographs in his office of the children he delivered. In addition to his medical career, Sabin was a valuable member of the community; he was involved in the Lions Club, the town council, and participated as the grand marshal at Windsor's Harvest Festival. An advocate of the sugar beet industry, he blew the whistle to officially begin production at the factory each year from 1934 to 1967. Sabin also served as the high school football team doctor and never missed a game. He is pictured with his rifle, which he used to mark the end of each quarter of every football game. To honor his devotion to the town, the high school (now middle school) stadium was named after him. (Windsor School District.)

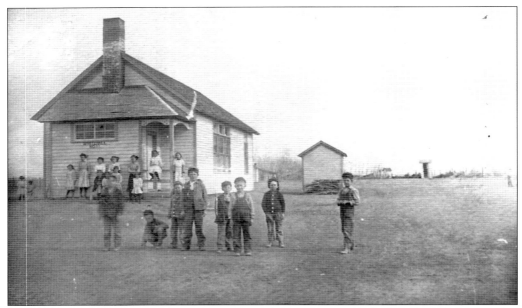

WHITEHALL SCHOOL, C. 1900. Windsor's school district was established in 1870, four years after the area's first school was built a few miles southwest of the town. Because of rapid population growth, Windsor residents established more schools throughout the area between 1870 and 1910 in Whitney, New Liberty, Riverside, Bracewell, Whitehall, Severance, and Oklahoma. Among the first teachers were Amelia Plowhead, Miss Brown, Emma Hubbell, and Mate Smith. (Windsor School District.)

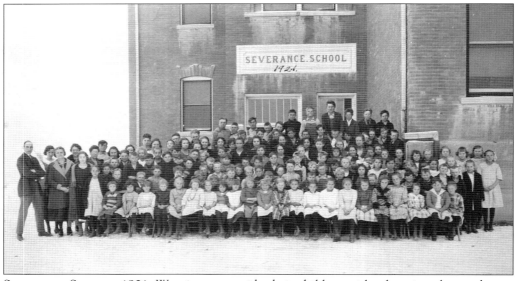

SEVERANCE SCHOOL, 1921. Wanting to provide their children with education close to home, Severance established a schoolhouse in 1885. A larger schoolhouse was constructed in 1907 that, according to superintendent L.H. Harrison, stood "without peer in the county." The school served the community until 1961, when the area was absorbed into the Windsor school district. (TWM.)

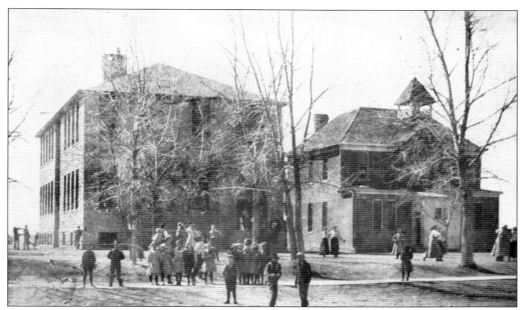

EARLY PARK SCHOOL, 1908. With a dynamic, growing population, Windsor residents continually adapted their schoolhouses. In 1883, residents moved the Whitney schoolhouse west, then razed the building three years later to construct a two-story, four-room brick building that was moved to Walnut Street; the structure is seen on the right after its relocation. The building on the left, Park School, went up next to the structure on Walnut Street and served as Windsor's first high school. (TWM.)

NEW PARK SCHOOL, C. 1910. By 1907, the school census listed 495 persons of school age in the district, with 207 of them being children of German-Russian parentage. To accommodate the increasing population, residents voted to expand Park School by constructing a western wing with eight classrooms and a third story as a large auditorium. The 1886 building was razed, and the new additions were constructed between 1909 and 1910. (Windsor School District.)

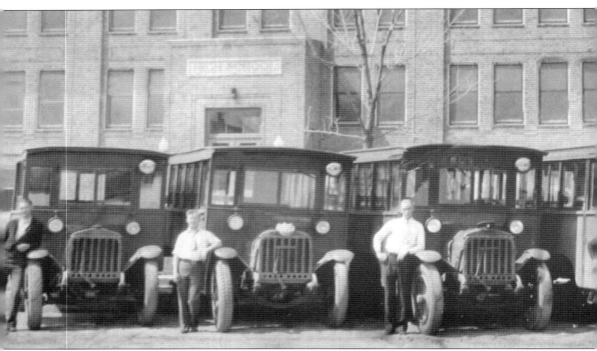

BUSES AT WINDSOR HIGH SCHOOL, C. 1930. In 1918, Windsor residents contemplated construction of a new high school building. Park School would remain in use as an elementary school, and the new high school would provide enough space for Windsor's growing student population. The town constructed this new school soon after, with George E. Tozer as its first principal. The school contained an auditorium, a stage, a gymnasium, a library, and nine classrooms. Immediate

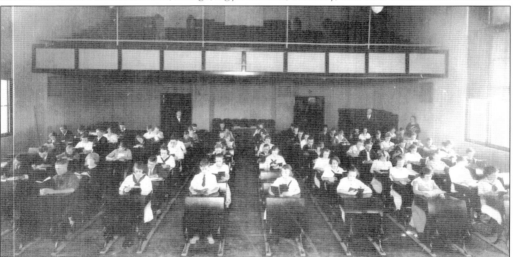

STUDY HALL. Before the school installed permanent seats, study hall was held in the open auditorium at Windsor High School. Schooling was also available during the summer for children who had to work in the beet fields; Windsor established the first program of this kind in Colorado, allowing children to maintain their studies before the beet harvest without falling behind. (Lois Tonguish.)

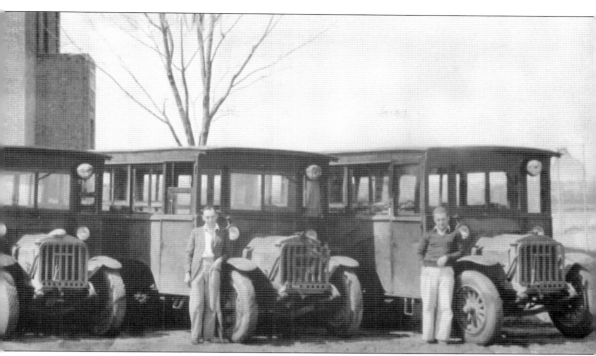

concern was voiced regarding the small size of the stage and gymnasium. In what was referred to as a "cracker-box" gymnasium, both athletes and spectators had difficulty avoiding the low ceiling and close-set walls; however, these issues were not addressed until the 1940s. In 1920, five school buses were purchased to transport children to and from rural areas; a sixth bus was purchased later to meet the demands of the growing population. (TWM.)

PLAYING AT PARK SCHOOL. While older students moved to the new Windsor High School (WHS) or the new junior high school, constructed in 1921, Park School remained the school for grades one through six. A.C. Cohagen served as the superintendent of the three schools from 1918 to 1931; George Tozer succeeded him. (TWM.)

WINDSOR HIGH SCHOOL FACULTY, 1930. Although several males served the school district as teachers, principals, or superintendents, the majority of teachers were females. Living in a small "teacherage" or with a family, unmarried female teachers were expected to abide by certain rules as part of their contracts. In 1915, a few of these rules included prohibitions on marrying, keeping company with men, loitering in ice cream stores, or wearing bright colors. (Windsor-Severance Historical Society.)

COHAGEN HALL, C. 1935. To cope with the increased number of children attending Windsor schools, the district hired several teachers. Due to the difficulty of finding lodging for numerous female teachers, the district constructed a building to house 32 teachers in 1921. Named after superintendent A.C. Cohagen, the Cohagen Hall teacherage served as the home for all female teachers for almost 30 years. (Denver Public Library, Western History Collection.)

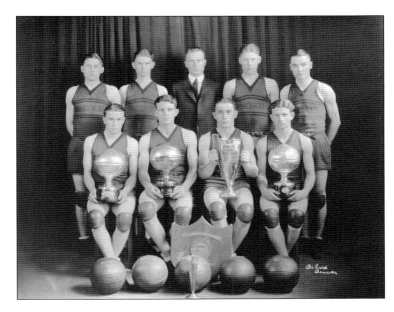

Basketball Team, 1924. Windsor gained national fame in 1924 when the Windsor High School basketball team won the US Basketball National Championship held in Chicago. The ball-handling wizardry of the WHS players under coach Joe Ryan impressed the Chicago media, who dubbed them "wizards" on the court. After the team returned home, the name stuck, eventually replacing the Windsor Bulldogs. (TWM.)

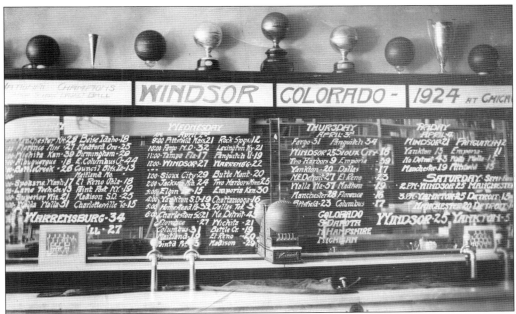

Keeping Score, 1924. During the championship, Frazier's Drug Store served up daily basketball scores along with fountain sodas. Updated scores were provided over the telegraph to the depot station agent, who ran scores across the tracks to the store, where they were listed on a mirror behind the counter. (TWM.)

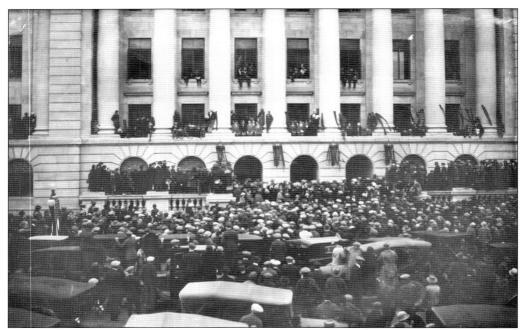

NATIONAL CHAMPIONS, 1924. After the Wizards triumphed 25-6 over Yankton, South Dakota, the team was welcomed home with much celebration. Colorado governor George Stapleton offered to honor the team on the steps of the state capitol, but Windsor mayor Roy Ray and superintendent A.C. Cohagen declined, wanting the celebration held in Weld County. Thousands of people met the train in LaSalle and followed the boys to Greeley's courthouse, above. On the way back to Windsor, hundreds of cars lined the highway, passing under American flags and Windsor's school colors hanging from telephone poles. Amidst the celebration held in front of town hall, coach Joe Ryan credited the town as the victors, stating that the boys had played for the honor of the school, its colors, ideals, and the town that helped make the way for victory. (Both, TWM.)

Three
WORKING THE FIELDS
AGRICULTURE IN WINDSOR

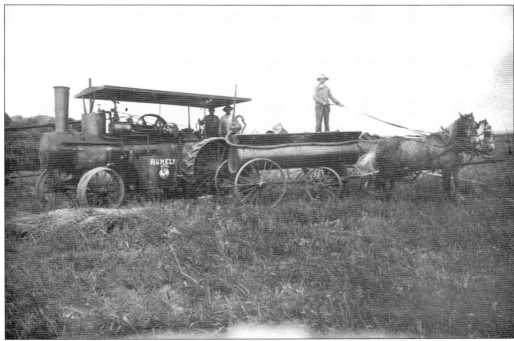

FARMING IN WINDSOR. As settlers from nearby colonies ventured along the Cache la Poudre River, they found ample opportunities for settlement and farming in the area that would one day become Windsor. Since those formative days, agriculture has been a staple of local life. Windsor farmers planted crops—including wheat, potatoes, hay, alfalfa, corn, cucumbers (for pickles), and sugar beets—and raised livestock. Windsor farms were generally associated with areas or districts named after nearby schoolhouses, including Bracewell, New Liberty, Oklahoma, Severance, and Wheatland. This is a wheat farm in the Oklahoma District, and the man standing in the wagon is Mr. Bradford. (TWM.)

FEEDING THE CHICKENS AND TURKEYS, 1915. One of the most prominent agriculturists in the Windsor area was Lewis Kern, a local land baron. Kern and his wife, Elizabeth, came to Colorado in 1871 and homesteaded a farm northwest of town. In addition to farming and raising livestock, the Kerns opened a post office on their ranch (known as Wheatland), one of the first to service the Windsor area. Kern sought to expand Windsor as an agricultural processing center, investing as a principal holder for the Bank of Northern Colorado in Windsor and furthering the development of irrigation and water interests. He contributed to the construction of several ditches and reservoirs and helped reorganize the Lake Supply Ditch Company as the Kern Reservoir and Ditch Company. Kern's son George F. Kern later took up farming and stock feeding with his wife, Isaphine, and daughter Carol. George Kern became a long-standing farmer in the area, operating a grain elevator and serving on the boards of several irrigation companies. Here, his daughter Carol feeds chickens and turkeys at the family farm. (TWM.)

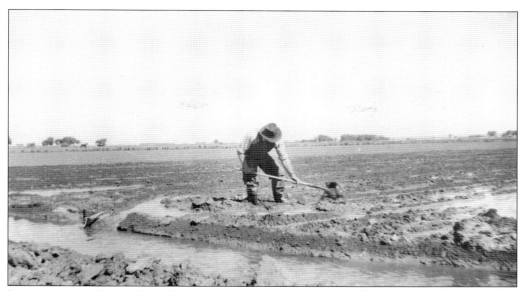

IRRIGATING THE LAND. One of the primary factors for growth in Windsor was the development of irrigation, which allowed farmers to settle and reap fruitful crops. In 1861, Fred Whitney constructed the first ditch in the area, Whitney Ditch, which diverted water from the Cache la Poudre River approximately one mile southwest of Windsor. The B.H. Eaton Ditch was the second ditch constructed in the vicinity. Here, Jacob Stromberger irrigates his farmland. (Betty Stromberger.)

THE NO. 2 DITCH. In 1886, John Cobbs and partners diverted water from the Cache la Poudre River approximately three miles northwest of Windsor for the No. 2 Ditch. Locals constructed several more ditches and reservoirs throughout the area, diverting the Cache la Poudre River to provide water for fields and stock. Water from the Big Thompson River reached southern lands like the Oklahoma District. (Jerry Marsh.)

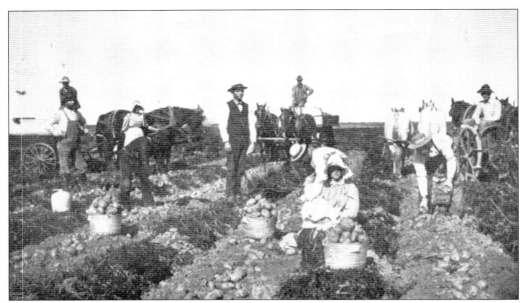

DIGGING POTATOES, 1908. Potatoes were one of the first crops cultivated in the Windsor area. Many mercantile stores in Windsor and to the northeast in Severance provided farmers and consumers with markets to sell and buy produce and grains. By 1917, Severance was known as one of the best "spud markets" in the area, selling loads of potatoes from near and distant farms. (TWM.)

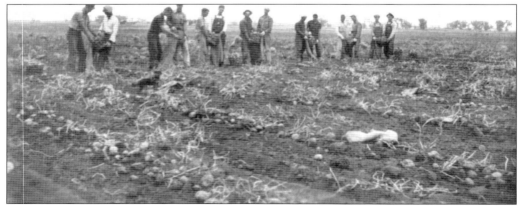

SACKING POTATOES, 1939. Here, field laborers sack potatoes at the Miller farm. Workers picked the potatoes by hand and placed them in wire buckets so dirt would fall out of the bottom. The potatoes were then transferred from the buckets to gunnysacks. Full sacks of potatoes stood in the field until a truck picked them up for storage or to sell at the market. (Gloria Gaslin.)

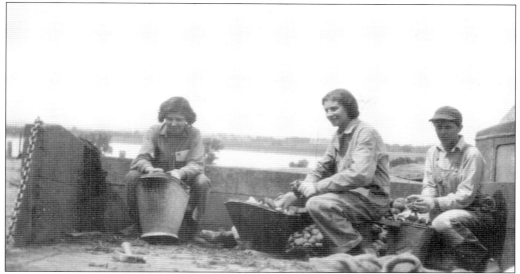

CUTTING POTATOES, 1930s. Here, workers prepare potatoes for planting. Workers each straddled a bench that had a knife on the end and cut seed potatoes into baskets, making sure there was an eye on each cut piece for planting. The cut-up seed potatoes were then put in sacks and covered with lime, readying them for planting. (John Dudley.)

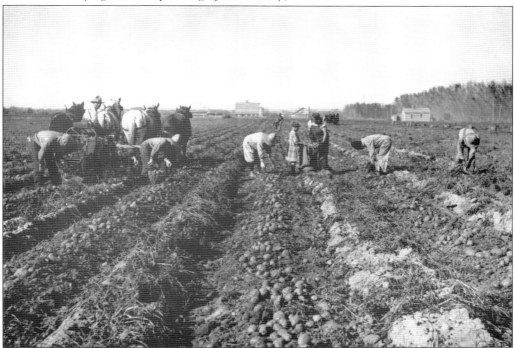

GERMAN-RUSSIANS IN POTATO FIELDS. Although most German-Russian immigrants worked in the sugar beet fields, they labored wherever there was work, including in the potato fields. Tenacious laborers, German-Russians did not consider women or children exempt from manual labor and took great pride in their work, often exclaiming, "*Arbeit, komm her, ich fress dich auf!*" ("Come, work, I will devour you "). (Colorado State University.)

GROWING WHEAT, 1942. Just two decades after they arrived, Germans from Russia owned the majority of farms and many businesses in Windsor. Fred Fritzler, shown standing in his wheat field, came to the United States from Russia in 1907 with his wife, Katherine. He purchased a farm in 1919 and another one in 1936, which he operated with his wife and two children, Paul and Louise. (Paul Fritzler.)

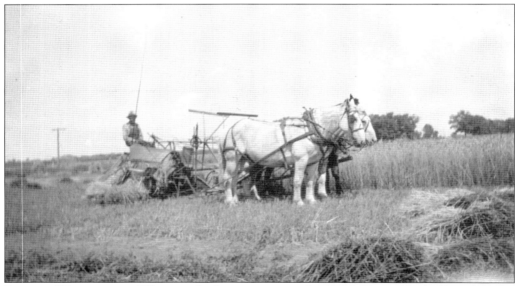

BINDING WHEAT, 1933. Wheat and other grains were the first crops to take hold in the area. Farmers harvested by cutting down the wheat with a binder. Before machines were able to bind and thresh together, farmers used horse-drawn binders like the one pictured here, which bound the grain in sheaves and deposited them on the ground. (Paul Fritzler.)

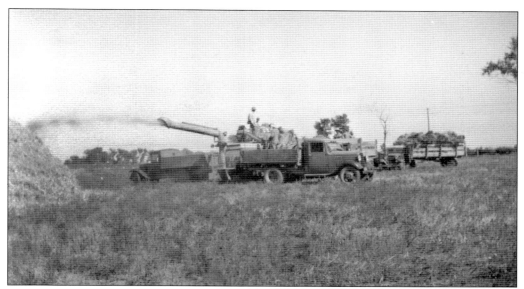

THRESHING WHEAT, 1941. During the early 20th century, neighbors all joined in the summer harvest, sharing labor and threshing machines to prepare wheat for the mill. While men worked in the fields using teams, wagons, drivers, and bundle pitchers to operate the thresher, women prepared meals for the workers. Here, Chris Paulsen (standing on machine) threshes while Fred Fritzler and William Wiedeman are on the truck. (Paul Fritzler.)

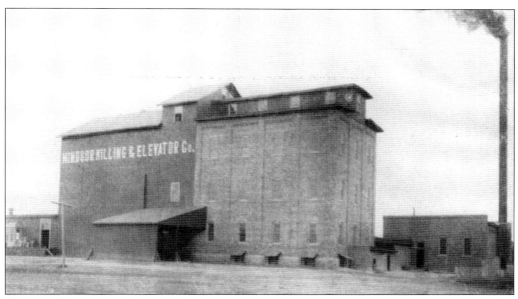

WINDSOR MILLING AND ELEVATOR COMPANY. As wheat became a major agricultural industry after 1900, the first manufacturing plant established in Windsor was a flour mill; the Windsor Milling and Elevator Company constructed it east of the stockyards. After the original mill burned down in 1899, the company built a brick mill with a frame elevator and warehouse at the corner of Main and Third Streets, pictured here. (Helen Casten Estate.)

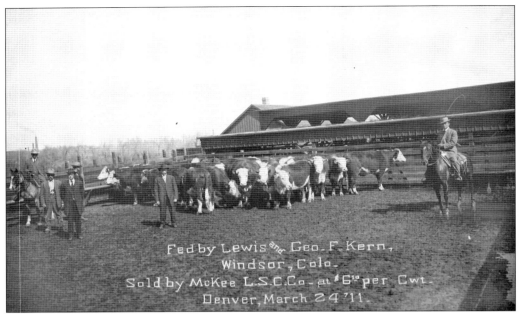

RAISING LIVESTOCK, 1911. In addition to planting crops, settlers in the Cache la Poudre hinterland raised livestock. The Kern family reared white-faced Herefords (above), a popular breed of cattle around Windsor. Local farmer Charles Sorrels made one of the biggest transactions in Denver in 1931 when he sold 10 carloads of cattle for $30,000; Sorrels's cattle earned the most profit the Denver Stockyards had seen until then. Raising livestock meant spending hours performing maintenance around the farm or stockyards. Below, from left to right, Paul Manweiler, Fred Foos, and Henry H. Rutz mend a corral and feed trough. (Above, TWM; below, Sue Buxmann.)

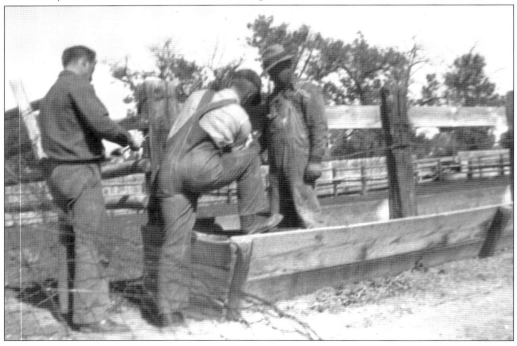

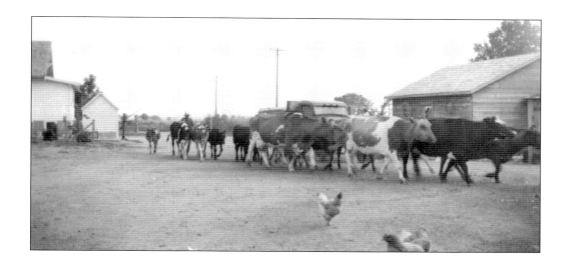

TRANSPORTING LIVESTOCK, C. 1942. After a long day of allowing their cattle to graze in pastures, farmers like Fred Fritzler drove them home, as shown above. When transporting cattle over great distances, farmers initially sent livestock by railroad; in the 1940s, cattle feeders switched to trucking. Since most stock raisers did not own trailers, they employed companies to haul livestock for them. The JJ Schaefer Livestock Hauling Company (below), located on North Sixth Street, had several trucks for transporting livestock. Windsorites who bought stock in Denver often sent Schaefer to transport them home. When it was time to sell, Schaefer hauled the livestock to whoever bought them. (Above, Paul Fritzler; below, Gloria Gaslin.)

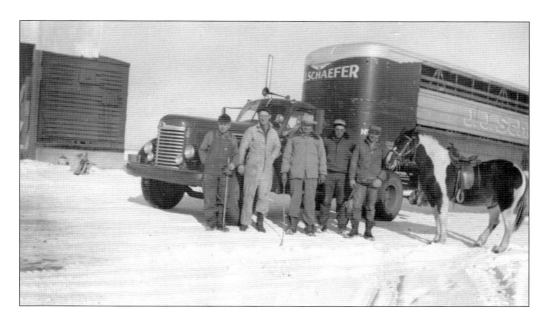

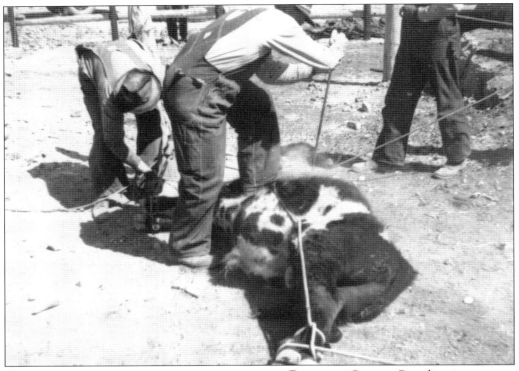

BRANDING CATTLE. Branding is a technique in which farmers use hot irons with their particular brand to mark livestock to identify its owner. Many Windsorites placed ads in the Windsor, Fort Collins, and Greeley newspapers offering rewards for the return of lost cattle marked with their brands. (Betty Stromberger.)

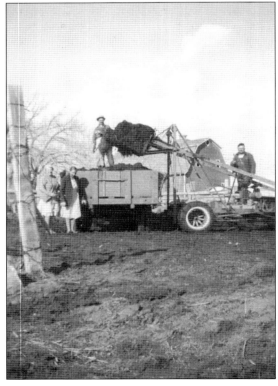

LOADING MANURE. To fertilize their crops, farmers spread manure over their fields. Local farmers either bought manure from neighboring cattle feeders or loaded it themselves from their own feedlots, as shown. (Kathy Heisel.)

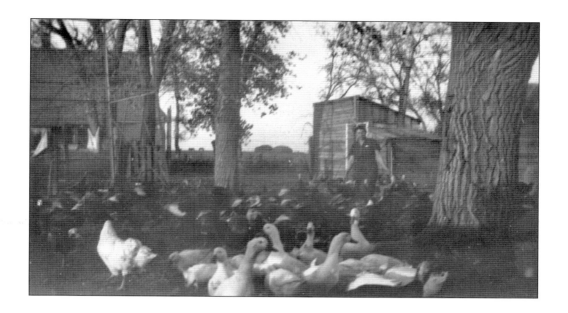

MORE THAN CROPS. Besides growing staple crops for sustenance and selling at market, Windsor farmers heavily relied on raising their own cows, pigs, turkeys, geese, and chickens (above) for daily milk, meat, and eggs. They also planted gardens full of beans, onions, cucumbers, dill, peas, watermelon, cantaloupe, grapes, cabbage, chamomile, rhubarb, hollyhocks, and dahlias. German-Russians particularly loved to plant blackberry, which they called "wunderberry." Some Windsor farmers also liked to raise bees for honey, which they sold (and also kept for themselves). Below is Theo Sorenson, who, in addition to raising sheep and serving as mayor of Windsor, kept bees on his farm. (Above, John Dudley; below, TWM.)

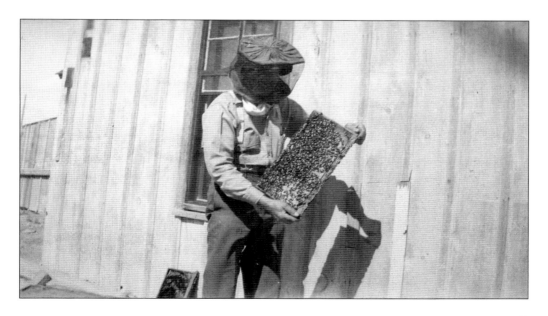

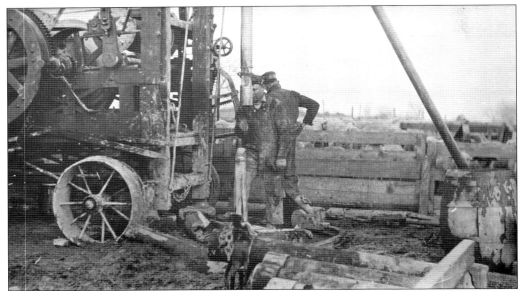

RAISING SHEEP. Raising sheep was also a lucrative industry in Windsor for many years. George Kern and Theo Sorenson had two of the largest sheep operations. Kern alone fed nearly 6,000 lambs in 1954. Above, workers prepare to dig a well next to the sheep pens, while workers in the photograph below shear sheep for wool. (Both, TWM.)

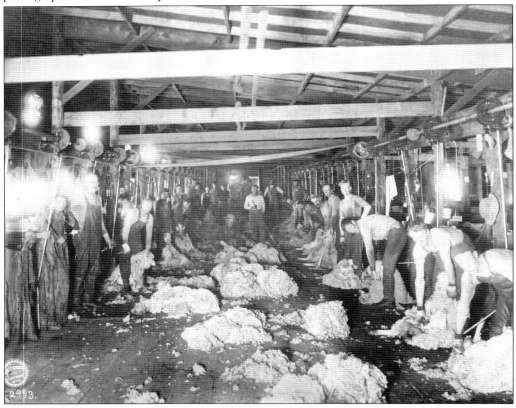

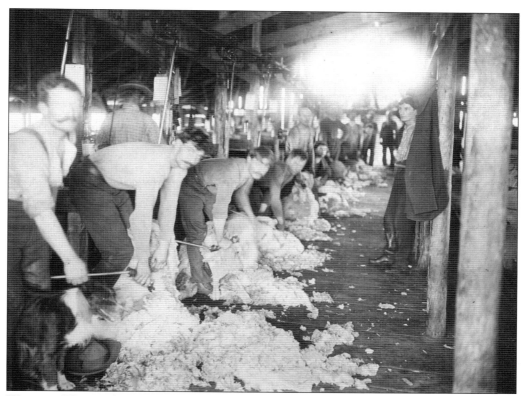

WINDSOR WOOL. The most profitable wool buyer in Windsor was Harry Murphy. Starting out small, Murphy began buying wool from local sheep farmers in Windsor, like those pictured above, to sell in Denver. In 1960, he became the wool-buying agent for the North Central Wool Marketing Corporation in Minnesota. Murphy's wool purchases from local farmers provided Windsorites the opportunity to market their wool nationally. Murphy later formed his own company, Murphy Wool and Livestock, and continued to market Windsor wool nationally, as well as to Japan, England, and France. Like cattle, sheep and wool were initially transported by railroad and later by truck. In the c. 1960 image below, John Weiderspoon (in the driver's seat) moves his sheep down Main Street on their way to be sheared. (Above, TWM; below, Kathy Heisel.)

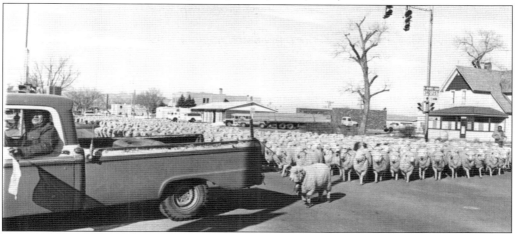

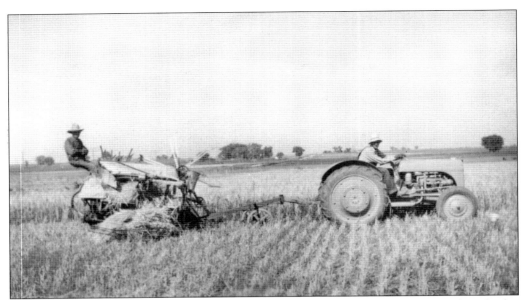

CUTTING GRAIN, 1944. Besides wheat, Windsor farmers grew small grains, such as barley and oats. As with wheat, farmers harvested grains with a binder that tied nearly 10 pounds of grain stalks into a bundle, then dumped the bundle on the ground. Women and children stood bundles against each other to make a shock, which was then picked up and taken to the thresher. (Paul Fritzler.)

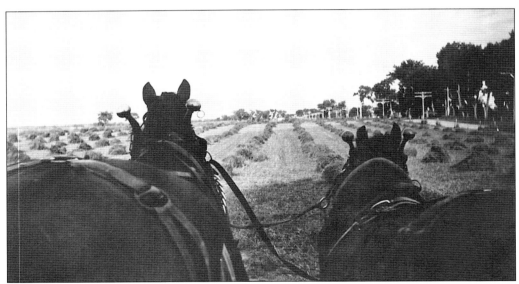

HARVESTING HAY, C. 1941. Farmers who planted alfalfa in Windsor generally got three cuttings of the crop each year if water was plentiful. The alfalfa or hay was cut with a sickle bar mower, first pulled by horses and later by tractor. It was then raked into rows with a dump rake or a side rake. Here, Fred Fritzler (not pictured), being pulled by his horse team, rakes hay just east of his house. (Paul Fritzler.)

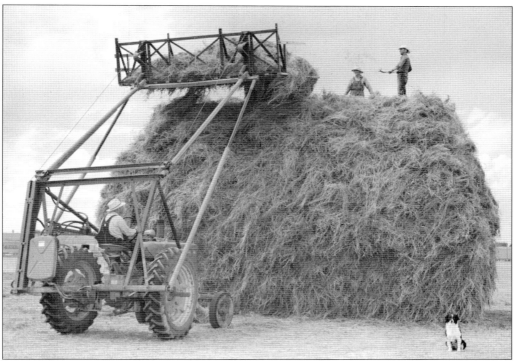

STACKING HAY, C. 1945. After the hay dried, a hydraulic loader was driven down the rows to gather it. It was a tricky job, as the operator had to make sure the teeth of the loader did not gouge the ground to keep soil from getting into the hay, which rendered it "poor quality." The stacker then lifted the hay to the top of the stack, where men would spread it evenly. Above, Fred Felte (on the tractor), Leonard Hoke, and Bill Webster work to stack their hay, while below, workers finish pitching hay onto the tractor. (Above, Jolieta Felte; below, Kathy Heisel.)

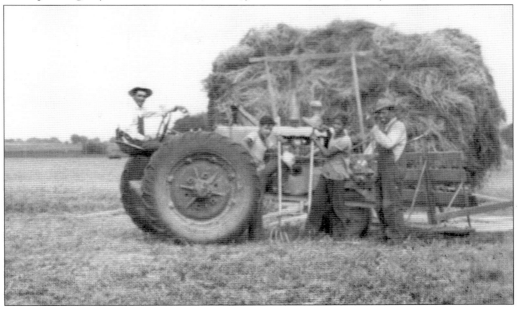

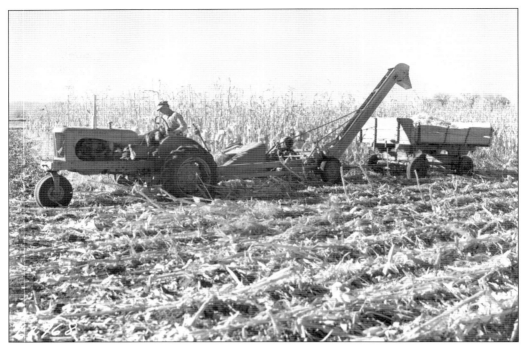

HARVESTING CORN. Windsor farmers generally planted corn to turn into silage for cattle feed. After the entire cornstalk was harvested, it was chopped and stored in a large pit in the ground, called an ensilage pit, to ferment. After fermentation, it was given to cattle and sheep for feed. This farmer is harvesting cornstalks with his new Allis-Chalmers tractor. (George Breniman.)

SCHMIDT FAMILY. Farming families were generally large and depended upon each family member's contribution to the production of the farm. Community was also an important factor, and families often helped one another with planting, harvesting, and farmwork by exchanging labor and equipment. Mr. and Mrs. Phillip Jacob Schmidt are pictured with a friend on their farm. (Paul Fritzler.)

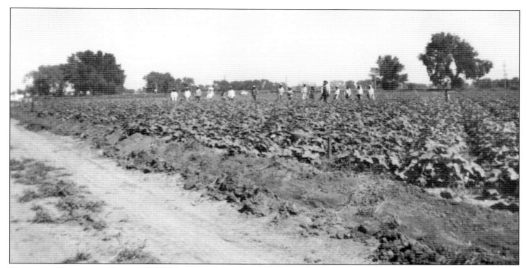

PICKING PICKLES. Around 1946, Windsor farmers began growing cucumbers for the H.J. Heinz Company. Referring to their crops as pickles instead of cucumbers, Windsor farmers accounted for 12 of the 78 top national pickle producers for the company. Here, laborers harvest pickles on John Weiderspoon's farm northwest of Windsor. Half of the money from the yield went to the farmer, while workers received the other half. (Kathy Heisel.)

HEINZ PICKLE FACTORY, C. 1950. In 1948, Heinz built a pickle-receiving station in Windsor. It constructed a second station in 1950, for a total of 110 salting tanks. Lloyd and Irene Lewis managed the stations from 1954 until the plant closed in 1972. The average yield per acre was around 400 bushels, equaling $500 to $1,200. (TWM.)

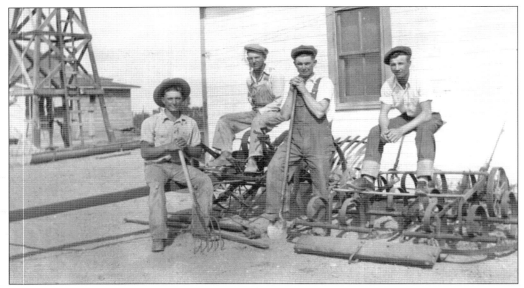

CHEWING THE FAT, 1934. While most days on the farm were spent laboring in fields or performing maintenance, young men were often able to work together and have some fun in the process. Here, from left to right, Fred Meisner Jr., Henry Meisner, Alex Meisner, and Victor Stroman take a break. (Paul Fritzler.)

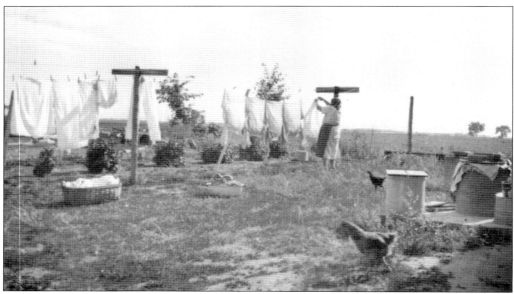

HANGING THE LAUNDRY, 1942. Women's work around the farm was just as demanding and important as work in the fields. Apart from cooking, cleaning, and laundering for family and hired hands, women supervised children, tended gardens, canned foods, made clothing, and labored in the fields. Here, Katherine Fritzler hangs laundry to dry—one of her many daily tasks. (Paul Fritzler.)

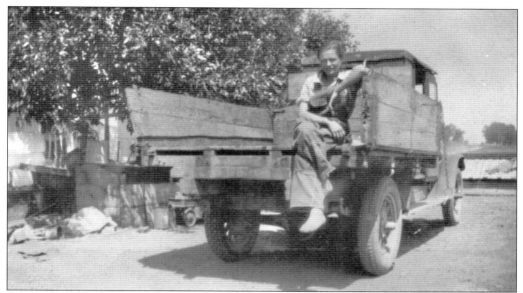

WOMEN AND TECHNOLOGY, 1931. Like many men who embraced new technologies for the farm, women utilized them, too. Women used new canning equipment, pressure cookers, and iceless refrigerators in the home. Outside, they used tractors to pump water for household chores. They also drove automobiles around the area to sell their produce and socialize. Here, Louise Fritzler sits on the back of the family truck. (Paul Fritzler.)

PLAYING ON THE FARM, 1921. Children generally helped with chores around the farm, but they took breaks for playing and going to school. Pictured here from left to right are Paul Fritzler, Henry Brunner, Louise Fritzler, Gearhart Brunner, and Hattie Brunner. (Paul Fritzler.)

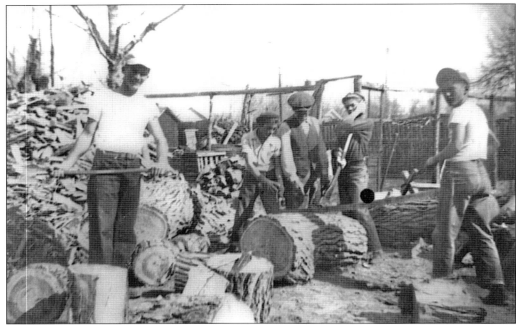

CHOPPING WOOD, C. 1945. Since farming required the participation of everyone, parents and grandparents made sure to teach children skills such as planting, cultivating, and harvesting crops, as well as milking, feeding livestock, and chopping wood. In this image, from left to right, Ben Lind, Elmer Lind, Grandpa Stoll, Paul Lind, and Robert Lind chop wood. (Robert Lind.)

SHOWING OFF THE NEW TRACTOR, C. 1952. All dressed up in patent leather shoes, Sue Buxmann climbed into the seat of her father's brand-new McCormick Farmall tractor and beet harvester. The bright red tractor came with a free freezer full of beef—an added benefit to acquiring new technology that reduced manual field labor. (Sue Buxmann.)

Four
Work Makes Life Sweet
Farming Sugar Beets

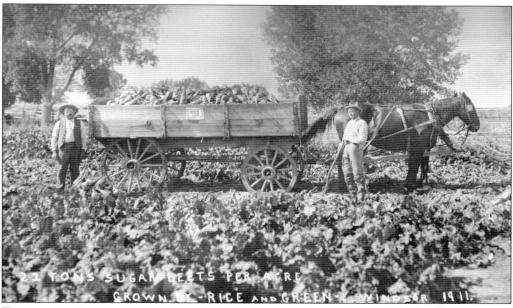

Twenty-two Tons of Sugar Beets, 1911. Cultivation of sugar beets in Windsor began around 1900 as a small enterprise. After two years of growing beets for the neighboring Loveland sugar factory, Windsor farmers found the soil and climate perfectly suited for sugar beets and increased their acreage of crops. Knowing they could sell harvests for higher profits and easily transport the crops if a factory were closer, farmers in Windsor and Severance began to talk of a sugar factory in Windsor. The Windsor Sugar Factory opened in time for the 1903 harvest—called a "campaign"—and set the area's largest boom in motion. Many farmers began exclusively growing sugar beets. Needing hundreds of inexpensive yet experienced workers to tend the labor-intensive beet fields, sugar companies brought hundreds of Germans and their families from Russia to northern Colorado. The gradual arrival of more than 600 German-Russian families forever changed the landscape of Windsor. Here, William Rice (left) and ? Green pose with their successful 1911 harvest. (TWM.)

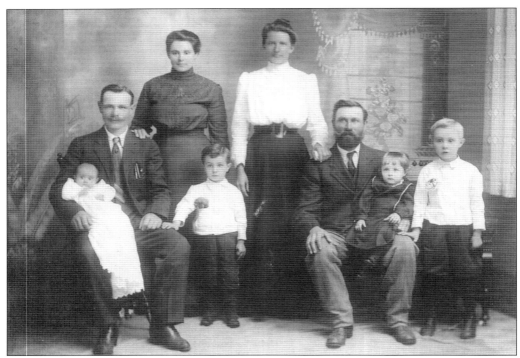

BUXMANN FAMILY, 1912. John and Maria Buxmann's family emigrated from Russia to the United States in 1907. Ethnically German, these families settled the Volga River area of Russia during the 18th and 19th centuries at the invitation of Catherine the Great and Alexander I. From left to right are Elise, John, Maria, Robert, Mary (Winter), John's brother George, Tillie, and Henry Buxmann. (Sue Buxmann.)

JOHN JACOB FRITZLER. Despite pledges of land and freedom, German colonists in Russia faced cultural persecution, repealed liberties, forced assimilation, and starvation. Promise of economic and personal freedoms lured many German-Russians to the United States, where non-citizens could acquire land under the Homestead Act. Five of John Jacob Fritzler's children immigrated to the United States between 1902 and 1912, sending money and food back to their parents. (Paul Fritzler.)

KATHERINE ELIZABETH FRITZLER. Katherine and her husband, Fred, son of John Jacob Fritzler, emigrated from Grimm, Russia (a village along the Volga River), in 1907. As German-Russians began arriving in the fall of 1902 in felt boots, long sheepskin coats, broad caps, and black shawls, Windsor locals received them with mixed reactions. While many businesses welcomed new customers, others ranged from cautious to xenophobic. As they had done in Russia, German-Russians preserved their Germanic heritage and were initially not willing to assimilate in northern Colorado. German-Russian families isolated themselves on the edges of fields or in their own neighborhoods, attended their own churches, and patronized German-speaking shops. Tensions between the English-speaking population and immigrant Germans escalated during World War I, and ethnic segregation became commonplace. (Paul Fritzler.)

Jacob and Carl Meisner. Despite their segregated start, within four decades, German-Russians like the Meisner family moved from the edges of society to become an integral part of the Windsor community. They purchased and improved thousands of acres of land, put their surnames on storefronts, participated in civic events, and gained citizenship. With so much German-Russian influence, many joked that Windsor was better pronounced "Vindsor." (Paul Fritzler.)

Sugar Beet Shanty. Since housing in Windsor was initially scarce, many German-Russians lived in temporary housing known as beet shanties. The shanties were small, rectangular buildings sided with planks and black tar paper, with a kitchen, one bedroom for sharing, straw mattresses, cupboards, a coal stove, and a table and chairs. With the black tar paper on the walls, some referred to their shacks as "black velvet homes." (Fort Collins Local History Archive.)

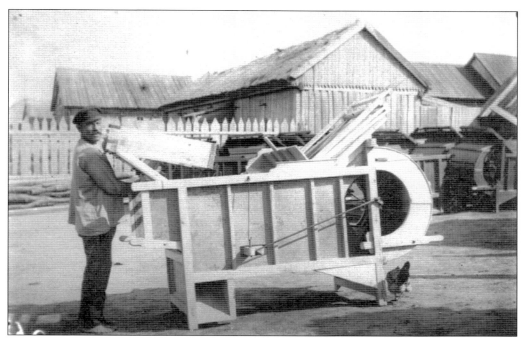

GERMAN FANNING MILL. German-Russians brought many traditions and farming techniques from Russia. As agriculturalists trained on the Russian steppes, they utilized their knowledge of mud-brick home construction and dry-farming techniques, as well as the use of the homemade fanning mill. The fanning mill (also known as a winnower) removed the wheat shaft from the grain. (Ron Greenwald.)

GERMAN FOUR-SQUARE ON LOCUST STREET, 1914. Many German-Russians built homes—generally square, four-room structures—in their own neighborhoods south of Main Street. One of the neighborhood streets, Locust Street, became the throughway for farmers to transport loads of beet pulp for their livestock. The dripping beet pulp would accumulate in the street, engendering the nickname "Pulp Avenue." (Paul Fritzler.)

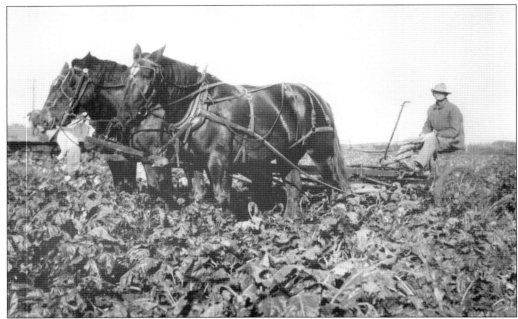

A WELL-SUITED JOB. Because Windsor immigrants were late in taking advantage of inexpensive land, plentiful work in the sugar beet fields was a saving grace. German-Russians had long grown the beet as a garden crop for its sweet, dark syrup. They offered the sugar beet industry expertise, an incredible work ethic, and large families to provide the labor necessary to turn sugar beets into a sugar boom. (Colorado State University.)

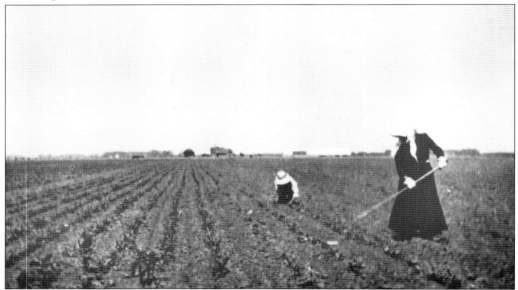

WOMEN AND CHILDREN IN THE FIELDS. Before child labor laws, company executives happily employed children. They found that children were better suited for stoop labor, especially thinning beets, because of their shorter legs and smaller hands. Since wages were paid according to the amount harvested, entire families were required to work in the fields for long hours to ensure a larger yield of crops. (Colorado State University.)

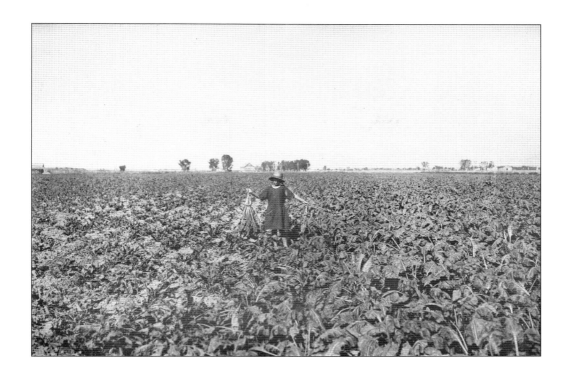

CREATING THE BEST CROP, C. 1930. The success of the sugar beet industry in northern Colorado was not only aided by widespread irrigation, railroads, and a large labor force, it also benefited from the improvement of beet varieties and cultivation techniques. Nearby Colorado Agricultural College (now Colorado State University) scientists worked with the Great Western Sugar Company to increase the sugar content and per-acre yield of sugar beets, making Larimer and Weld County sugar beets the best in the world, according to the US Department of Agriculture. The girl pictured above stands in a demonstration field to display the effects of a lack of irrigation. The crop on the left had less water, yielding smaller beets than the crop to her left; however, she is holding the representative beets in the wrong hands. Below, workers pile beets by hand into rows for pick up. (Above, TWM; below, Betty Stromberger.)

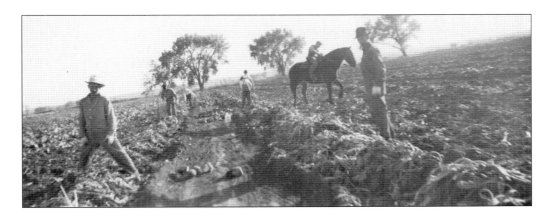

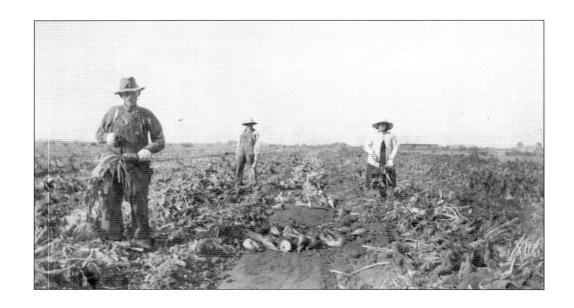

CULTIVATING BEETS. A labor-intensive crop, sugar beets were typically planted in March, cultivated the entire summer, and then harvested in October. Farmers initially managed weeds by densely planting the crop, which laborers manually thinned with hoes several times during the growing season. After thinning, laborers removed weeds, being careful to not chop any beets. During the harvest, farmers used a beet puller to pull up the beets while laborers followed behind, picking up the beets, knocking them together to remove soil, topping them (removing the leafy portion), and then piling them in rows to be picked up. They then loaded the topped beets into a truck, which took the harvest to the beet dump. Above, from left to right, Fred, Louise, and Katherine Fritzler labor to top their beets. Below, Carl Swanson poses with a truckload of beets. (Above, Paul Fritzler; below, Wilma Swanson.)

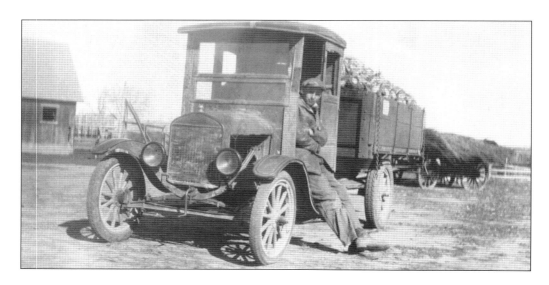

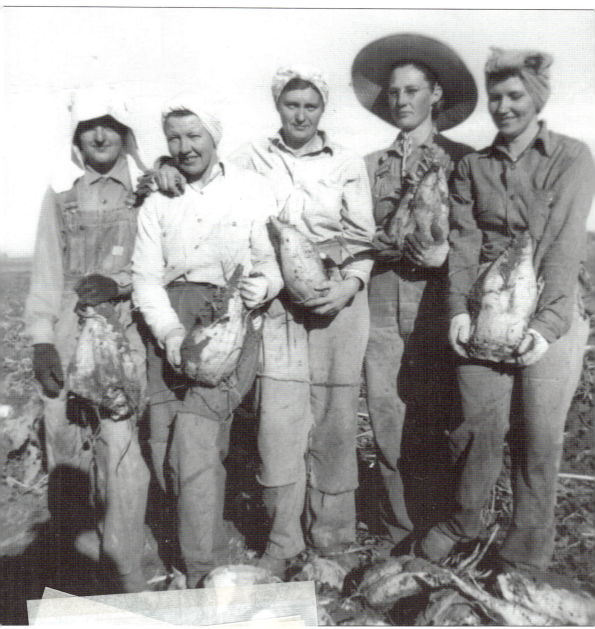

...bored in the fields from sunup until sundown, ... lunch. As German-Russians slowly adapted ... its and black shawls for American wear. By ... othing for working in the sugar beet fields, ... es. They often sewed canvas padding onto ... and blisters from crawling down the rows ... s, as the large beet knives had dangerous ... hair up with scarves or kept it under a hat ... ed beets. (Donna Knaus.)

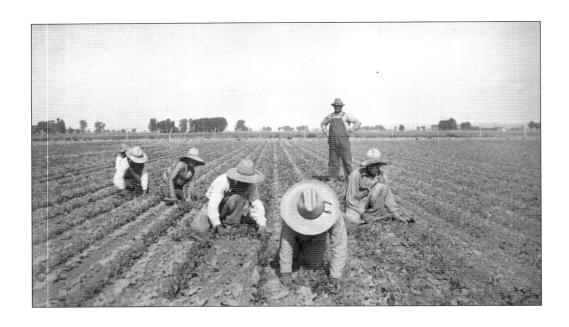

HISPANIC BEET WORKERS, C. 1940. As German-Russians became more established in Windsor, many no longer worked in the fields, instead purchasing their own farms or houses and working downtown or in the sugar factory. This shift, coupled with reduced immigration during World War I, left the Great Western Sugar Company struggling to find new laborers; it began recruiting Hispanic families from New Mexico, Arizona, Texas, and Mexico to work the sugar beet fields. The families established large neighborhoods in communities like Fort Collins and Greeley, much like the early German-Russian families. Hispanic families also quickly became an important part of the Windsor community, going beyond the beet fields to become active, engaged citizens. (Above, TWM; below, Paul Fritzler.)

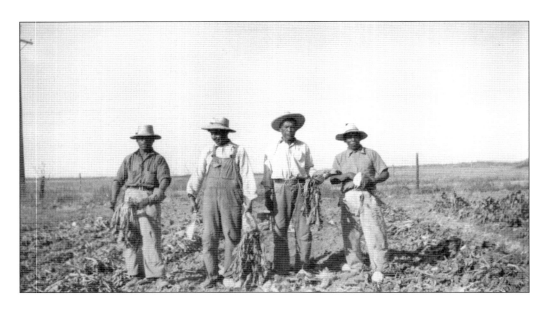

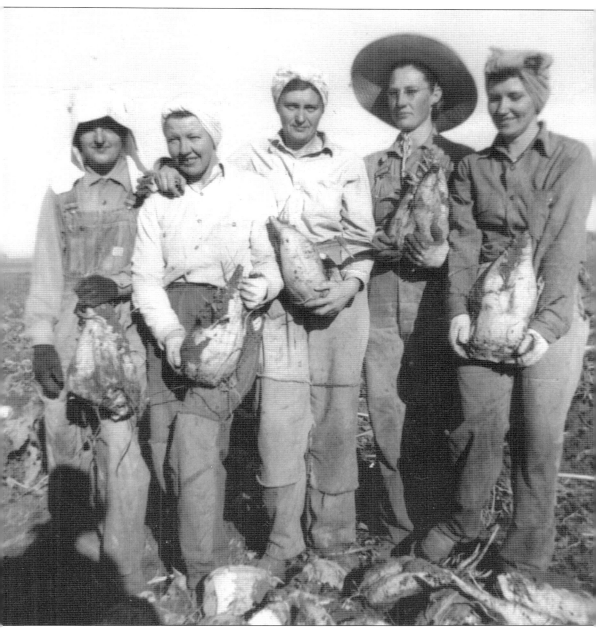

SUGAR BEET UNIFORM, C. 1940. Sugar beet workers labored in the fields from sunup until sundown, with short morning and afternoon breaks and time for lunch. As German-Russians slowly adapted to life in Windsor, they began swapping their long coats and black shawls for American wear. By the 1930s, men, women, and children wore similar clothing for working in the sugar beet fields, including long-sleeved shirts, bib overalls, and tall shoes. They often sewed canvas padding onto the knees of the pants to prevent both wear in the cloth and blisters from crawling down the rows of beets. Workers also wore gloves when topping beets, as the large beet knives had dangerous hooks. Women working the fields generally tied their hair up with scarves or kept it under a hat to stay cool, like these women posing with their topped beets. (Donna Knaus.)

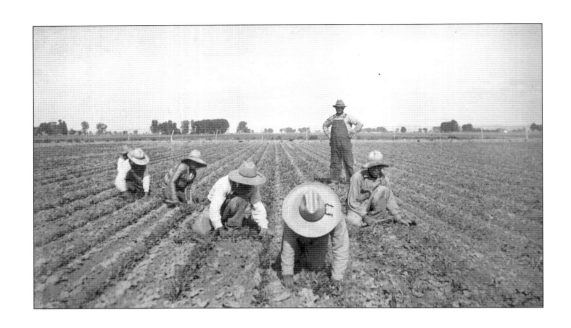

HISPANIC BEET WORKERS, C. 1940. As German-Russians became more established in Windsor, many no longer worked in the fields, instead purchasing their own farms or houses and working downtown or in the sugar factory. This shift, coupled with reduced immigration during World War I, left the Great Western Sugar Company struggling to find new laborers; it began recruiting Hispanic families from New Mexico, Arizona, Texas, and Mexico to work the sugar beet fields. The families established large neighborhoods in communities like Fort Collins and Greeley, much like the early German-Russian families. Hispanic families also quickly became an important part of the Windsor community, going beyond the beet fields to become active, engaged citizens. (Above, TWM; below, Paul Fritzler.)

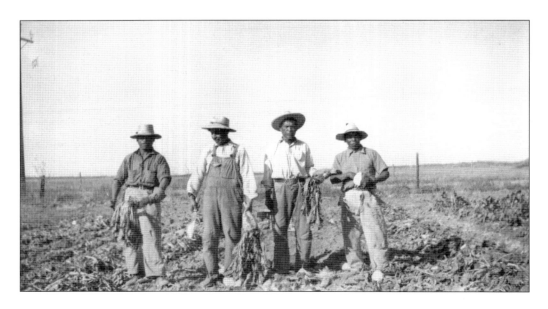

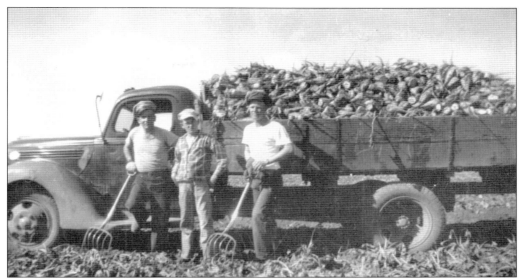

MECHANIZING THE HARVEST. Around the 1950s, the labor-intensive process involved in sugar beet cultivation—thinning, weeding, topping, and loading beets by hand—was replaced by mechanical sowing, herbicides, and mechanical harvesting. With new technology like the beet harvester, workers no longer needed to toil in the fields all summer or load beets by hand, like the three unidentified men pictured above. Rather, beet harvesters (below) topped the beets, lifted the roots, and removed excess soil in a single pass over the field, covering up to six rows at a time. As it made its way down the field, the harvester dumped the prepared beets into trucks ready for a trip to the beet dump. Mechanization also greatly reduced the need for a large labor force. (Above, Marge Straube; below, Kathy Heisel.)

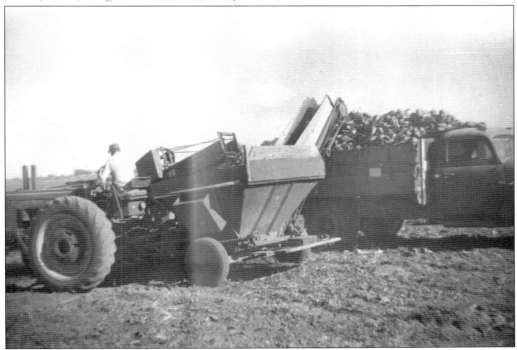

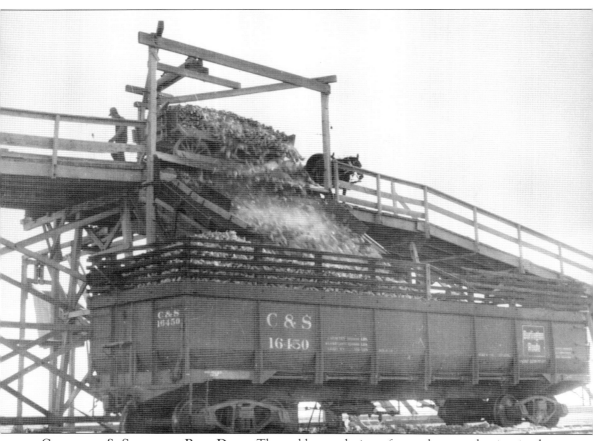

Colorado & Southern Beet Dump. The sudden explosion of sugar beet production in the early 1900s required Colorado to undertake construction of a massive agricultural-industrial infrastructure, namely through railroads. With the expansion of the railroads, farmers could efficiently transport their crops to the factories instead of hauling heavy wagonloads for miles. Sugar companies promoted a network of collection points along the rail line called beet dumps. The numerous beet dumps throughout the region reduced the distance farmers had to travel by wagon and truck. Farmers hauled loads up a gradual incline to a platform where the load was securely tilted and the beets dumped into the train car below. The Great Western Railway, a subsidiary of the Great Western Sugar Factory, provided the fastest delivery of beets to the Windsor factory. An enterprising industry with a large and devoted workforce, sugar beet production drastically changed Windsor. It was proud work felt by all, endearing the phrase "*Arbeit macht das Leben süss,*" which means, "work renders life sweet." (Colorado State University.)

Five
Sugar Beet Boom
The Great Western Sugar Factory

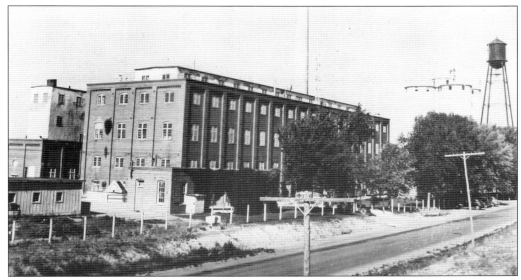

GREAT WESTERN SUGAR FACTORY, C. 1940. By 1900, Windsor had become a hamlet with expanding agriculture and a growing downtown. Almost overnight, Windsor became a sugar beet boomtown after locals and investors constructed the Windsor Sugar Factory in 1903. Local businessmen E.I. Raymond and H.C. Branch began promoting the construction of a sugar factory in 1901 by setting out to secure commitments of Windsor and Severance farmers to grow 5,000 acres of beets. Farmers rallied in support, creating a committee to obtain the necessary capital to construct a factory, with former Colorado governor Benjamin H. Eaton as chairman. After negotiating with three groups for financial assistance, the committee's proposals were agreed to by a group of Michigan investors who had constructed factories in Greeley and Eaton. Following the deal, the Windsor Sugar Company was officially incorporated and set up temporary headquarters in 1902. (TWM.)

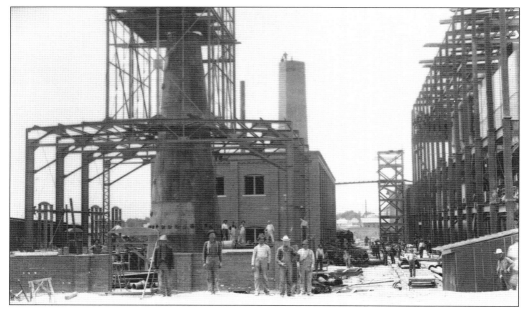

CONSTRUCTING THE FACTORY, 1903. The site for the anticipated factory was a section of the Hollister estate located just southeast of downtown. The sugar company hired the Kilby Manufacturing Company of Ohio to construct the 600-ton-capacity factory. To prepare the site for construction, workers leveled the land for water to drain onto adjacent land. (Colorado State University.)

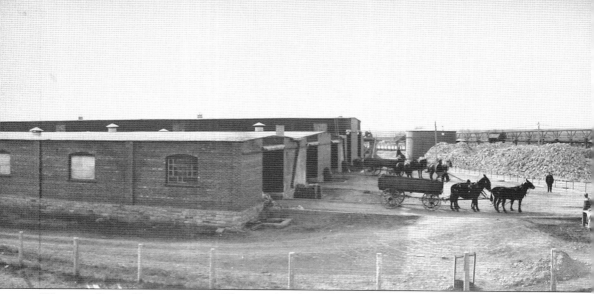

WINDSOR SUGAR FACTORY, 1903. The completed Windsor Sugar Factory was an impressive sight across Windsor's eastern horizon. On November 5, 1903, the factory opened for its first campaign with more than 250 men to operate the facility. While E.I. Raymond and H.C. Branch had hoped for one of the large sugar companies to purchase the Windsor factory after the first campaign, they were forced to shoulder the debt for a few more years. Despite this, the Windsor Sugar Company remained open and was finally purchased by the Great Western Sugar Company in

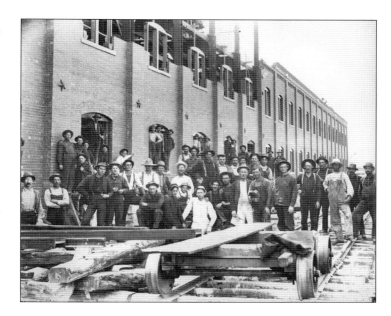

NEARLY FINISHED, 1903. The Kilby company built all of the structures using steel and concrete and clad the exteriors with redbrick. The crew installed machinery, using cranes to mount large equipment like crystallizers. The completed sugar factory grounds included a four-story main plant, a sugar warehouse, a boiler house with German-imported sugar boilers, administration offices, a smokestack, and a limekiln. (Colorado State University.)

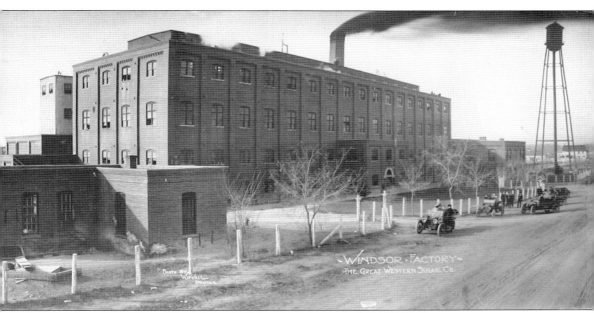

1905. The Windsor factory proved to be one of Great Western's busiest, consistently exceeding its daily capacity and doubling the factory capacity in 1908. Now assured of an annual income, Windsor bankers and businessmen extended credit to beet farmers and laborers and began to further develop the town and their own businesses. The arrival of the sugar factory radically and permanently altered the burgeoning town. (TWM.)

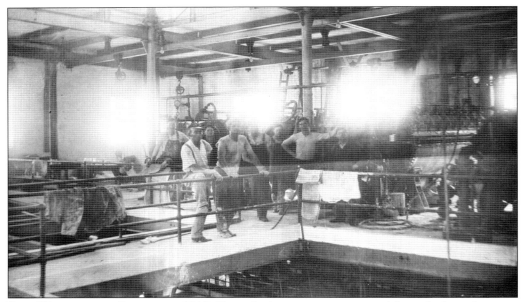

BEET WASHING AND SLICING, C. 1915. Once the beets were transported from the beet dumps to the factory, they were poured into a wet hopper and floated into the factory through a flume to be washed. The first stop in the process involved removing mud, sand, rocks, weeds, leaves, and trash from the beets. Once clear of debris, the beets moved into the washer, where they were dewatered. The beet-washing station is pictured above. After being washed, the beets moved to the beet-slicing station along a hopper. At the slicing station (below), beets were mechanically sliced with sharp knives into long strips referred to as cossettes or noodles. (Both, TWM.)

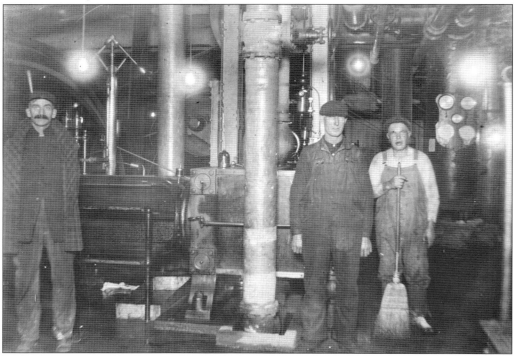

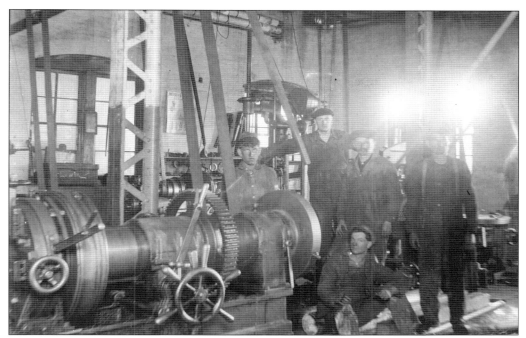

DIFFUSION PROCESS, C. 1915. Workers at the knife-sharpening station (above) made sure the blades at the beet-slicing station stayed sharp to cut the cossettes. From the slicers, the cossettes traveled along a conveyor belt to be weighed and fed into the diffusion battery (below). Within the battery's cells, hot water kept at a stable temperature washed over the cossettes to extract the sugar. The resulting sugar water, called raw juice, was then sent to the next stage of the process—purification and filtration—while the exhausted cossettes were pressed and dried for sale as livestock feed. Diffusion batteries had to remain constantly in circulation during the campaign for the factory to run efficiently. (Both, TWM.)

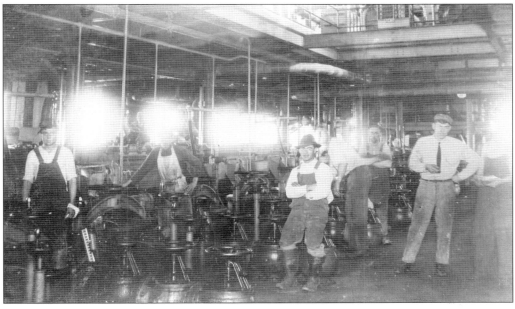

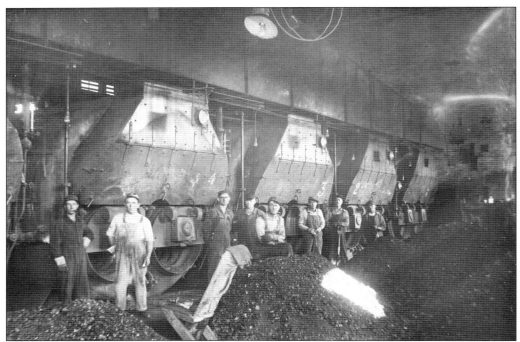

PURIFICATION AND EVAPORATION, C. 1915. After leaving the last cell, the raw juice was ready for clarification. During the purification process, workers added burned lime from the limekiln (below) to the raw juice. The juice then went through two carbonation stations, where it was filtered to eliminate impurities and developed the right consistency for evaporation. The filtered juice, now called thin juice, was then heated and fed into evaporators. Heat from steam provided by the boilers (above) evaporated water from the juice, reducing it into a thick, light-brown syrup called thick juice. Thick juice was then sent to a melter, where the sugars dissolved from high heat. During the final stages of processing, the juice was fed into a pan, where centrifuges separated the crystallized white sugar from the thick brown liquid. (Both, TWM.)

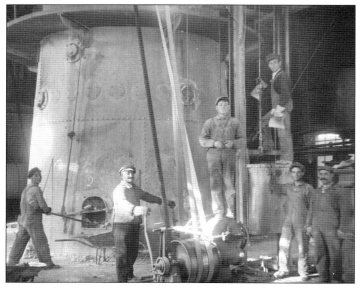

SUGAR TRAMPS, C. 1915. Known as "sugar tramps," the men and women who worked for Great Western held many different positions—each integral to the factory's production and efficiency—including superintendents, chemists, enginemen, mechanics, electricians, machinists, pipefitters, and oilers. These sugar tramps pose in the maintenance room; with so many machines and moving parts, maintenance was a never-ending job. (TWM.)

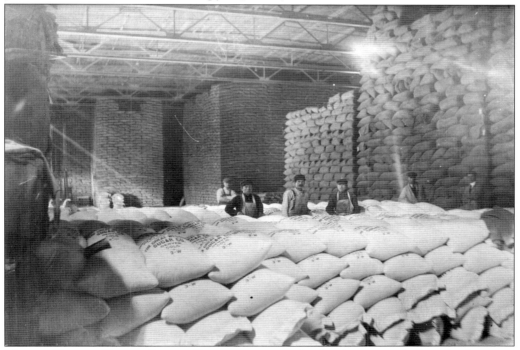

MILLION-DOLLAR PILE OF SUGAR. Sugar tramps stored refined sugar in cloth sacks that were piled high in the warehouse. Before sugar made it into the sacks, workers shoveled dried sugar out of bins and into an auger to be finely ground and then filled 10- or 100-pound sacks with the refined sugar. Workers often wore the sacks over their shoes and pant legs to walk through the sugar. (TWM.)

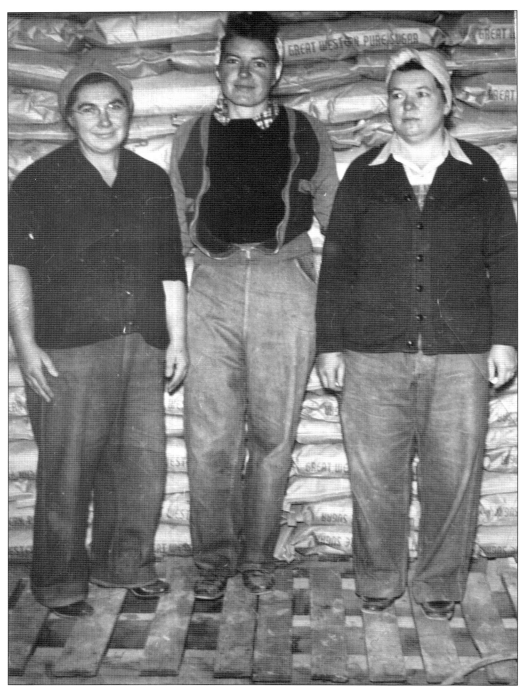

WOMEN AT THE FACTORY, C. 1940. Women put in long hours alongside their male colleagues during the sugar campaigns. They worked as telephone operators, bookkeepers, cooks, timekeepers, and purchasers, and they packed sugar into sacks as well. Pictured from left to right are Mary Bott, Leah Felker, and Kate Weinmeister, who packed sacks at the Windsor factory. (Cocks-Clark Graphics, Inc.)

Henry Kisselman Sr. A longtime employee of the Windsor factory, Henry Kisselman Sr. was a devoted sugar stacker. Although he was offered many promotions, Kisselman turned them all down to remain a stacker. He and his family emigrated from Russia in 1913. His two sons, Henry and William, also worked the sugar campaigns. (TWM.)

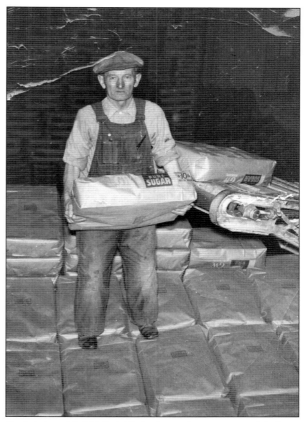

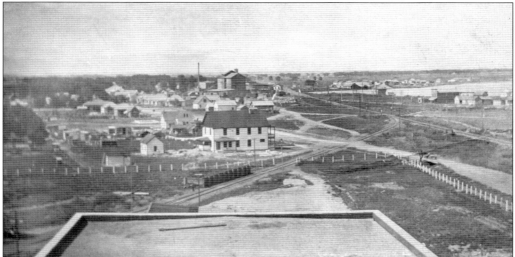

Sugar Factory Hotel, c. 1910. The large two-story building in the center of the photograph is the sugar company's hotel. Located west of the factory, the hotel opened in time for the 1907 sugar campaign and housed many workers in need of living arrangements. The sugar company expanded the hotel with two additions in 1918 and 1919, respectively. As demand for housing continued to grow, the sugar company constructed several more residences throughout town. (TWM.)

Campaign Winner, 1928. The Windsor factory gained notoriety as the most efficient Great Western factory for the 1927–1928 sugar campaign. In a contest among 20 other factories, Windsor did not win because of speed, but rather by "maintaining a constant steady pace from the beginning to the end of the campaign." The Windsor sugar tramps pose in front of the factory with their pennant. (Windsor-Severance Historical Society.)

A Good Place to Work. The Great Western Sugar Company was known as a company with a heart, comprised of managers who cared about their employees and farmers. The company offered all employees never-before-seen salary and benefit packages, made high-profit and fair-labor contracts with beet growers, and constructed affordable employee housing. Here, Windsor managers and foremen stand in front of sugar stacks. (TWM.)

Carl A. Hurich, 1958. By 1940, the Windsor factory employed 45 people year-round, increasing the workforce to about 260 during the sugar campaigns. The company's corporate farm employed a steady force of 50 men, which increased to 275 during the planting season and to 175 during the harvest. Hurich served as a beet end foreman for the company for several years. (TWM.)

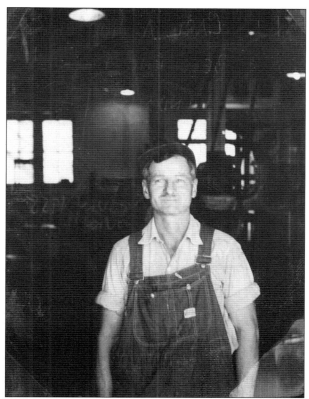

An Innovative Company, 1960. Among northern Colorado's sugar beet towns, Windsor had the distinction of being selected to host Great Western's own nearly 2,000-acre corporate farm. The farm grew seeds, conducted agricultural experiments, and implemented new technologies for harvesting. Here, company sugar tramps pose on sugar sacks during the 1960 campaign. (Wilma Swanson.)

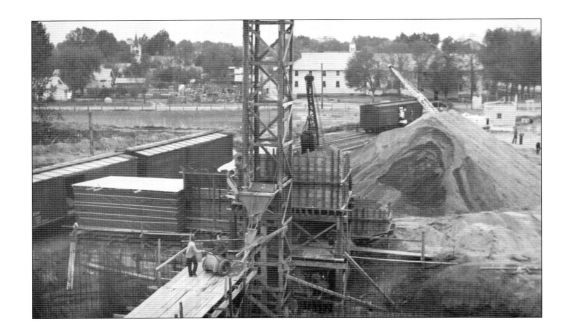

CONSTRUCTING THE SUGAR BINS, 1940. During the summer of 1940, the Windsor factory constructed large storage bins for raw sugar. These included four sugar bins in a cloverleaf arrangement with an elevator shaft in the center. Each bin was 110 feet tall and 35 feet in diameter. The bins had a total capacity of 200,000 bags of bulk sugar. Windsor was the second factory (after Fort Morgan) to build such storage bins. (Both, TWM.)

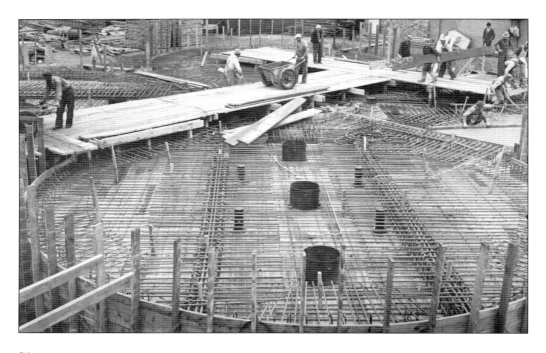

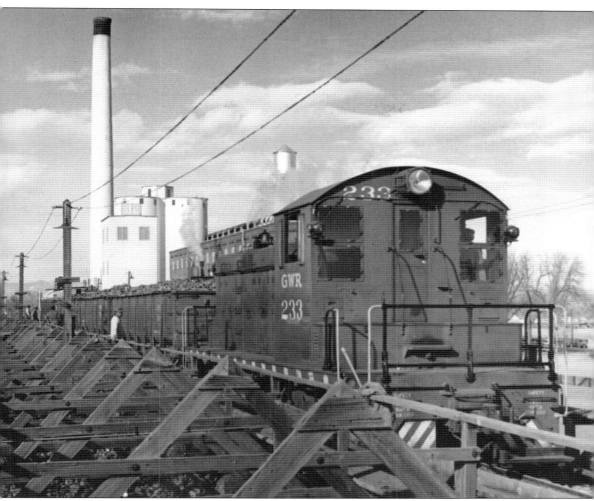

Great Western Railway. Incorporated in 1901 by the Great Western Sugar Company, the Great Western Railway constructed a densely connected network in northern Colorado to service the sugar beet industry. Because harvested sugar beets metabolized sugar content at a rate of one to two pounds per day per ton, moving them quickly was a necessity. Thus, the railway sought to efficiently join beet dumps with factories. Between 1901 and 1904, the railway laid its first section of track east from Loveland through Johnstown to Hillsboro-Milliken. The railroad then planned to connect Loveland and Eaton by way of Windsor and Severance. Severance had been promised a railway tie when its farmers pledged to grow beets in support of a Windsor factory. The railroad completed the Windsor-Eaton route in 1905 and finished the line from Loveland to Windsor in 1906. With this portion of track complete, the Colorado & Southern, which had helped with construction, handed over the yard and switching operations at Windsor's sugar factory to Great Western. (Colorado State University.)

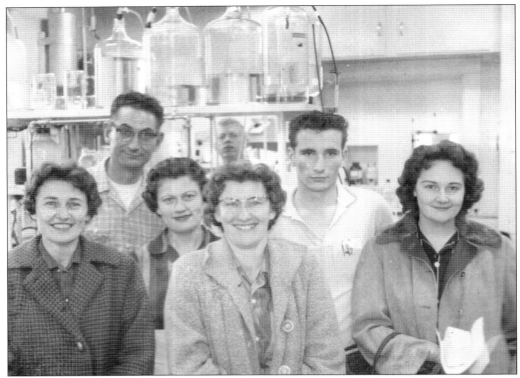

THE SUGAR LAB, 1960. Great Western employed several chemists and technologists throughout its factories to research and develop methods for extracting the maximum amount of sucrose from the sugar beet and the resulting byproducts from the refining process. This group is working in the lab at the Windsor factory. (Wilma Swanson.)

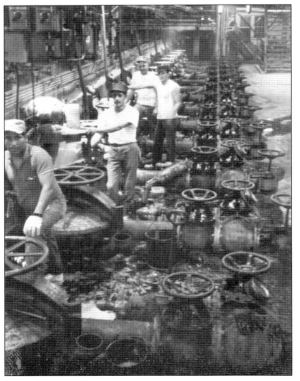

REPEATING THE PROCESS. While technological advances were made in the cultivation of sugar beets as a crop and the refinement of byproducts such as molasses, not many changes were made to the basic process of refining sugar. Sugar tramps at the Windsor factory in the 1950s and 1960s used similar equipment and processes as their predecessors had during the first sugar campaign in 1903. (Wilma Swanson.)

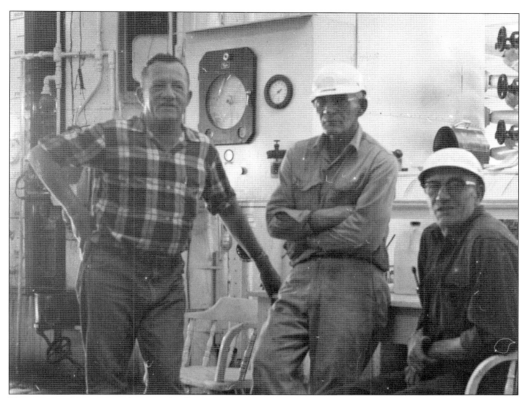

END OF AN ERA. Windsorites had grown up in awe of the process that "created fine white sugar from cartloads of dirty, heavy sugar beets," as local James Frazier put it. The largest single business in Windsor, the Great Western Sugar Company made an economic effect by supporting the town and employing many of its residents and farmers through the first half of the century, including, from left to right, (above) Alex Brunner, Pete Felker, and Ed Hemmerle and (below) Ed Williams, Charles Chipman, and Dave Berens. During its tenure in Windsor, the company paid a total of $12 million in salaries to its employees. The closing of the sugar factory forced many Windsorites to move and/or find new employment. As a result, Windsor entered a period of decline. (Above, Marge Straube; below, TWM.)

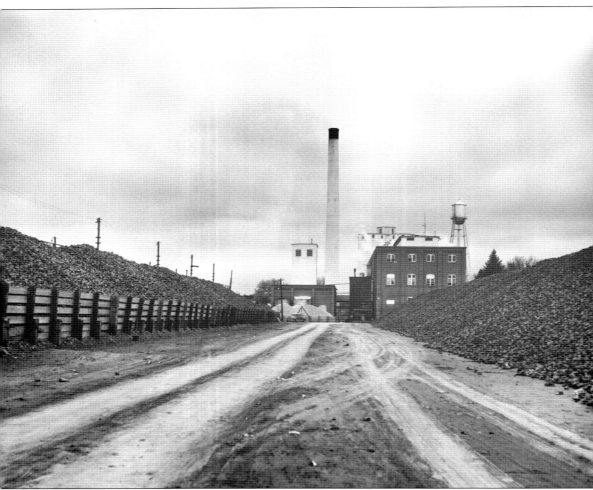

THE ROOT OF DECLINE. Despite its once-booming prosperity, the sugar beet industry started to decline in the 1940s. The world market for sugar dramatically diminished after two World Wars and the Great Depression, resulting in the elimination of tariffs and subsidies that were sustaining the sugar beet industry. Sugar beets, like those piled high along this factory lane, were no longer the white gold they once had been. Because of debased prices, growing the sweet crop was no longer a profitable venture for Colorado farmers, and many decreased their acreage. As a result, Great Western closed the Windsor factory in 1966, much to the dismay of the town. In 1977, the majority of the plant was demolished. Today, the remaining silos, a few ancillary buildings, and the smokestack are all that remain of this once-sweet part of Windsor. (Colorado State University.)

Six

Mid-Century Town
Business, Community, and Recreation

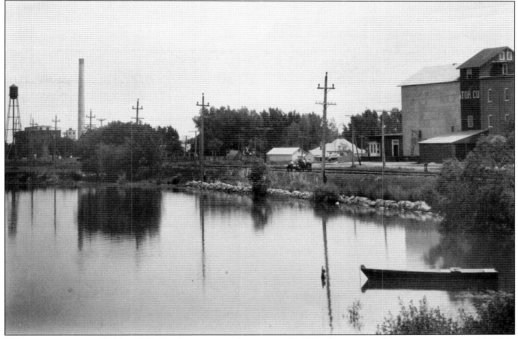

Windsor in the 1940s. While the sugar industry made Windsor into a boomtown, the mid-20th century led Windsor into a period of decline. Between 1930 and the late 1960s, the population of Windsor was reduced by half, from a high of nearly 3,000 to just 1,400 in 1967. Several factors led to the downsize. The decreased demand for sugar and mechanization in the beet fields required fewer laborers, most of whom left the area seeking new work. The closure of the Great Western Sugar Factory, which had been the town's largest employer, also dispersed Windsor residents. Moreover, the increased mobility provided by automobiles and highways allowed Windsor-area laborers to live elsewhere. While these events stunted Windsor's growth, the remaining residents continued to open and patronize businesses, make town improvements, and carry on with life. Pictured here are, from left to right, the Great Western Sugar Factory, Windsor Lake, stockyards, and the Windsor Milling and Elevator Company. (TWM.)

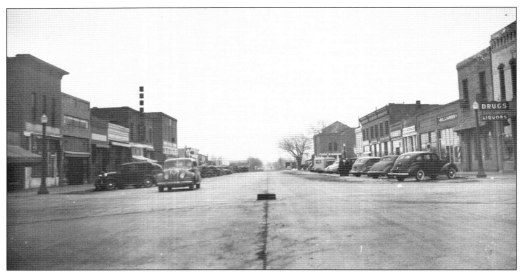

MAIN STREET, C. 1949. With the rise in popularity of the automobile, Windsor positioned itself as the best route between the Weld and Larimer county seats. Several businesses opened to cater to this industry, including dealerships, repair garages, and service stations. The designation of Main Street as both State Highways 257 and 392 increased Windsor's stature as a highway town and brought in travelers who patronized local businesses. (TWM.)

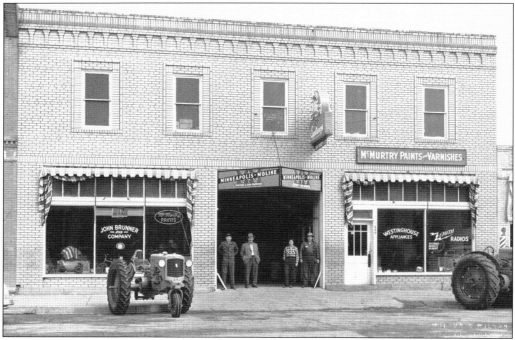

JOHN BRUNNER AND COMPANY, C. 1946. In 1946, John Brunner and Sons moved its farm implement and appliance shop to its new location at 512 Main Street. Since 1920, the Brunners had repaired farm equipment, provided electrical and plumbing contracting, and sold Minneapolis-Moline farm machinery, Eversman land levelers, Westinghouse radios and appliances, Westinghouse and Zenith televisions, and Youngstown kitchens. (John Brunner.)

STREEB'S REPAIR SHOP, C. 1940. Gerhard and Henry Streeb operated Streeb's Repair Shop, one of many garages, for 27 years. The Streebs specialized in Dodge and Plymouth automobiles but repaired all automobiles and tractors, advertising "we repair all makes." Pictured here from left to right are Henry Streeb, G.O. Streeb, and mechanic Lawrence Warner. (Gordon Streeb.)

WEST ON MAIN STREET, C. 1940. Throughout the years, many established Windsor businesses kept their doors open—though often under new management—including Community Cold Storage and the Windsor Mercantile Company. Main Street also witnessed the comings and goings of several new shops, cafes, and bakeries, including the Ben Franklin Store, Lieser's Drug Store, Tripp's Shoe Shop, Suzie Q Bakery, Peggy Lee clothing shop, and the Li'l Flower Shoppe. (TWM.)

FRAZIER'S DRUG STORE, C. 1940. In 1953, L.E. Frazier's nephew Francis "Jim" Frazier took over the family business. The drugstore featured a fountain with several stools, tables, and booths at which to enjoy "Frazier's special concoctions"—customer favorites included "chocolate shorts" and "tin roofs." After Jim Frazier sold the shop in 1963, the store closed for good in 1964, ending a 61-year tradition. (Jim Frazier.)

SCHOOLBOOKS, 1953. Along with tasty concoctions, Frazier's was the only store in town that sold schoolbooks. At the end of the school year, children returned the books to Frazier's for a small refund. When business was slow, soda jerks headed to the basement to erase the pencil marks in the returned books. (*Windsor Beacon*.)

MORRIS STORE, 1944. Morris and Dora Karowsky stand in front of their shop, the Morris Store, which they opened in 1928. Jewish immigrants from Russia, the Karowskys offered a variety of ready-made clothing, shoes, and dry goods. They were forced to close their store in 1956 because of ill health. Other local clothing stores throughout the years included Olson's, Gambles, and Ehrlich's. (Charles Karowsky.)

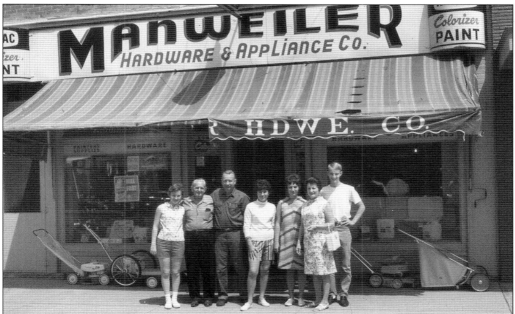

MANWEILER'S HARDWARE, C. 1960. After arriving in Windsor, George and Lena Manweiler opened a blacksmith shop, which soon evolved into a farm equipment dealership and then a hardware and appliance store. George's son Herbert and Herbert's wife, Alma, took over the store and expanded the business. Pictured here are, from left to right, Carol Manweiler, Fred Schaefer, Herbert Manweiler, Pat Foley, Janice Manweiler, Alma Manweiler, and Charlie Manweiler. (Charles Manweiler.)

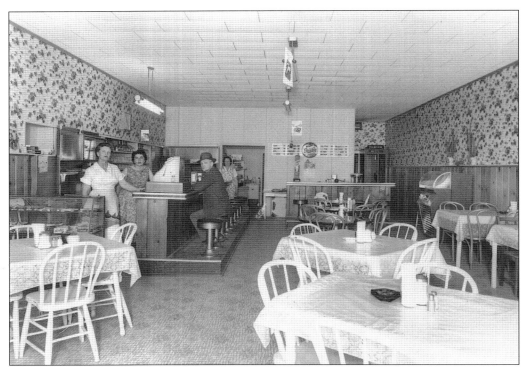

STAR LITE CAFE, C. 1953. Inez Flinn operated the Star Lite Cafe between 1953 and 1968. Many Windsor residents often met at the cafe for dinner meetings or to socialize. The cafe later became known as the Stock Exchange, then the Duke of Windsor. Pictured here are, from left to right, Flinn, waitress Gloria Walter, unidentified, and cook Portia Daugherty. (Windsor-Severance Historical Society.)

MOREY'S SALVAGE AND GLASS, C. 1950. Originally a hotel, the property at 124 Main Street eventually became a salvage yard, with rooms occasionally rented to seasonal sugar factory workers. Owner Dave Winograd extended the salvage yard across the street in the early 1940s to help the railroad ship steel for the war. In 1951, the Morey family bought the business and constructed a new building to replace the old hotel. (Tracey Morey.)

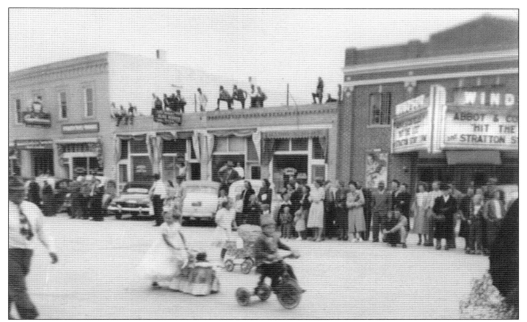

WINDSOR THEATER, 1943. A popular stop along Main Street was the Windsor Theater (far right), operated by G.I. Richards for 36 years. Shows, originally costing a nickel, served as a chief source of entertainment for those in and around town. Newspaper editor Roy Ray described the Windsor Theater as "the first theater outside of Denver to incorporate the latest and most modern sound features and film production room." (Lydia Hettinger.)

BASEBALL FIELD, 1952. Summertime baseball was a favorite activity held at the ballpark near the Lakeview Cemetery on the eastern edge of town. Bleachers, new lights, and a refreshment stand installed in the park between 1947 and 1952 allowed spectators and players to enjoy more games. Windsorites enjoyed being at the baseball diamond so much, parking spaces by the fence were auctioned off so that winners could sit in their cars to watch games. (TWM.)

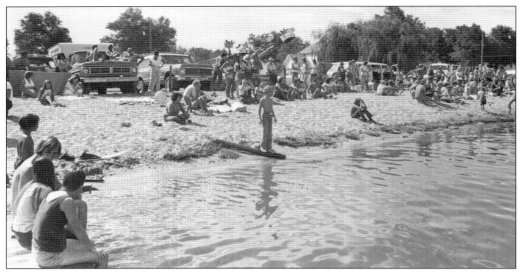

WINDSOR LAKE, 1976. After a lull for more than 20 years, Windsor Lake once again became a center for recreation. After the Windsor Boating and Fishing Club organized in 1952, the town opened the lake up for swimming in 1957. In 1959, the town moved much of the annual Harvest Festival activities and carnival to the park south of the lake. (Windsor-Severance Historical Society.)

MARBLE CLUB, C. 1950. Like earlier Windsorites, residents often found entertainment and fellowship by joining groups like the Optimist Club, Woman's Club, and Garden Club. Although this was known as the Marble Club, the 8 to 16 women who met monthly actually preferred playing Chinese checkers with homemade boards. Desserts and coffee were served as part of this meeting, where women came to socialize. (John Dudley.)

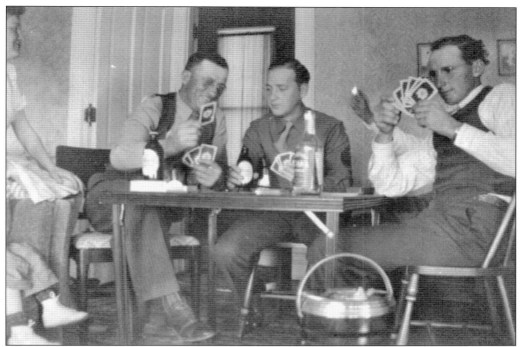

PLAYING CARDS, 1943. On weekends, farmers and their families often came to town for entertainment. Children attended movies at the Windsor Theater, women went shopping, and men socialized at the pool hall or played cards at friends' homes, with pinochle being the game of choice. From left to right, Irma Fritzler, Alex Brunner, Arthur Gordman, and Paul Fritzler play cards at Henry Walter's home. (Paul Fritzler.)

ENJOYING WATERMELON, 1943. Watermelon was a favorite treat among Windsor German-Russians. Many residents grew watermelons for summertime refreshment and enjoyed sour watermelon into the winter. After stacking unripe melons in barrels, brine and spices were poured over the watermelons to sour them. While members of the older generation, like Mary Fritzler (center), enjoyed the sour slices, younger descendants preferred their watermelon fresh. (Paul Fritzler.)

FIRST DIAL TELEPHONE, 1962. Telephone service debuted in Windsor in 1896, when the town had three subscribers. Four years later, Windsor secured a telephone exchange with a 20-line capacity, which was housed at the G.H. Peterson hardware store. Later innovation came in March 1962, when the first dial telephone was installed in the residence of Mayor Glenn Anderson. Pictured from left to right are unidentified, Ken Coleman, Lorraine Anderson, and Glenn Anderson. (Lorraine Anderson.)

AMERICAN LEGION ANNIVERSARY. Many of the organizations that came to Windsor in the early 20th century continued to have active participants well into the 1980s, including the Masons, Eastern Star, and the Odd Fellows. The American Legion Auxiliary, pictured celebrating an anniversary, worked to benefit veterans and their families and participated in local parades on Memorial and Labor Days. (Henry Haas Estate.)

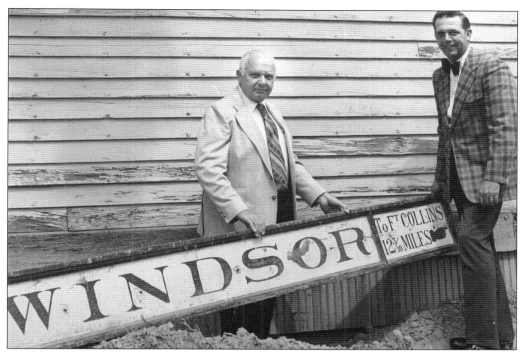

WINDSOR DEPOT MUSEUM. When the Colorado & Southern Railroad decided to replace its original 1882 depot with a newly constructed building, community members organized to save the historic depot from being torn down. Many locals, including Suzanne Rosener and Robert Hogan, worked with the town and railroad; the depot was eventually moved to its current location at Boardwalk Park to serve as a museum. Above, Howard Smith (left) and Hogan hold a sign from the original depot. The museum opened during Colorado's bicentennial year in 1976, inspiring the formation of the Windsor-Severance Historical Society, which operated the Depot Museum (below) for several years. The depot is now part of the Town of Windsor's Museum at Boardwalk Park. (Above, TWM; below, Greeley History Museum.)

PRISONER OF WAR CAMP, C. 1943. In 1943, the federal government purchased land southeast of Windsor for a prisoner-of-war camp, which held 3,000 German prisoners. Initially alarmed at having a POW camp so close, Windsor farmers were eventually grateful to have extra labor during the harvests. Prisoners, accompanied by guards, earned good wages and enjoyed eating and working with Windsor farmers with whom they could speak German. (TWM.)

W.L. MCCALL, C. 1943. One of Windsor's most beloved teachers and principals, W.L. McCall served the school district for 36 years as the backbone of the English department. He and his wife, Mildred, loved enriching the lives of Windsor's students and community. Here, McCall poses in front of the POW camp, where he served as a liaison between farmers and prisoners. (Sue Buxmann.)

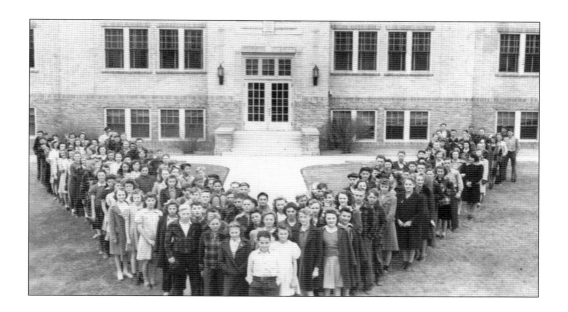

WINDSOR SCHOOLS, 1942. By 1940, Park School, the junior high school, and the high school still taught all of Windsor's children. World War II had many effects on Windsor schools, including the establishment of a wartime schedule and allowing time off for tending victory gardens and rationing. Students did their parts to support the war effort, buying and selling war bonds and sewing clothing. Above, junior high students show their patriotism in a V-for-victory formation. Below, from left to right, Olverina Smith, Lydia Detterer, Verna Rutz, and Ruth Altergott sew clothing in their ninth-grade home economics class. After the war, the smaller school districts were consolidated with Windsor. The town considered expanding the schools but had to construct a new junior high school after the original school caught fire in 1964. (Both, Lydia Hettinger.)

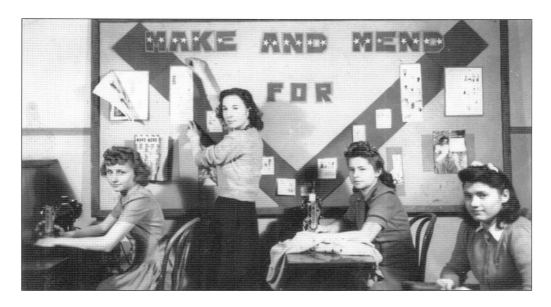

PROM, 1955. Expansion within the school district began with the addition of a new high school gymnasium to replace the old "cracker-box" gymnasium. With room for bleachers, locker rooms, and elaborately decorated proms, the new gymnasium was acclaimed by everyone in town. (Kathy Heisel.)

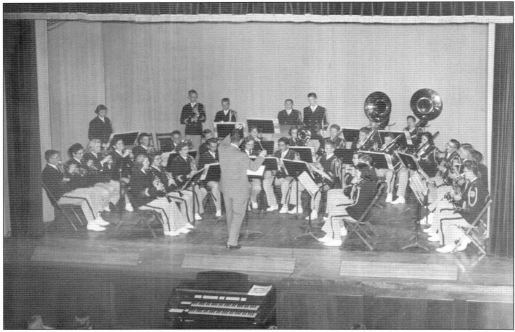

WINDSOR HIGH SCHOOL BAND, 1959. The newly renovated auditorium at the Windsor High School hosted many school activities, including concerts by the highly acclaimed WHS band, conducted by Gerald Gilliland. The band continually won high ratings at Colorado University Band Days during the 16 years Gilliland taught. After Gilliland retired, Ed Ranum continued the tradition of excellence. (Sue Buxmann.)

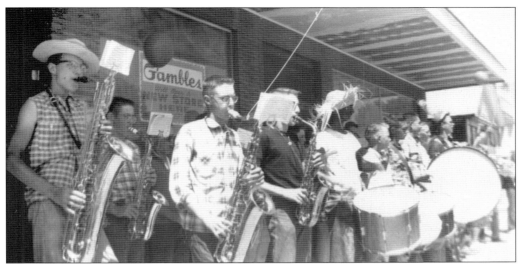

WINDSOR HIGH SCHOOL BAND, 1960. To prepare for the school year, in the summertime, the WHS band practiced marching up and down the streets of Windsor to ensure its lines were straight; amused younger children and dogs followed the band throughout town. The band played in several Windsor parades and festivals. Here, the band plays in front of Gambles for Windsor Crazy Days, a large downtown business sale. (Sue Buxmann.)

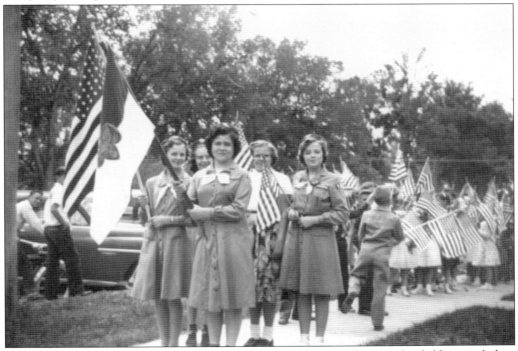

MEMORIAL DAY, 1955. Several organizations offered entertaining education for children, including 4-H Club and scout troops. The traditional Windsor Memorial Day Parade brought many clubs together, including the Windsor High School band, Boy Scouts, and Girl Scouts. The groups lined up at the Methodist church with flowers and flags and followed the American Legion Color Guard to the Lakeview Cemetery in honor of veterans. (Windsor-Severance Historical Society.)

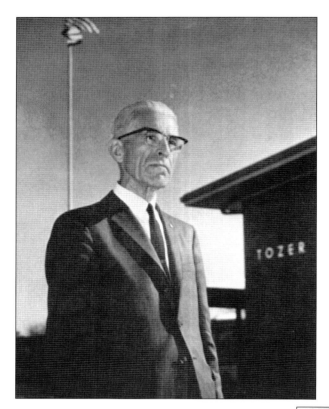

George Tozer. Tozer, who became the superintendent of Windsor schools in 1931, devoted his career to refining the curriculum. He hired specialized teachers to provide better classes for children, worked to maintain the budget, and sought higher salaries for his teachers. The elementary school constructed in 1959 was named in his honor. (Windsor School District.)

Virginia and Mary Alice Lindblad, c. 1940. The daughters of Union Colony settlers, Virginia (left) and Mary Alice Lindblad were well-known teachers and residents of Severance. With degrees in education from Colorado State College (now University of Northern Colorado), they taught in the Windsor school system for more than 20 years. After retiring, Mary Alice wrote two local histories, *A Walk Through Windsor, 1940–1980* and *Tales of Tailholt: The Story of Severance*. They are pictured walking in downtown Greeley while in college. (Sandy Lee.)

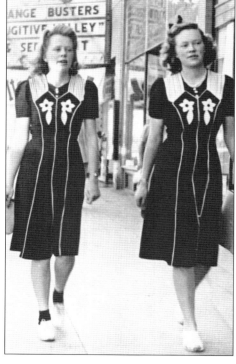

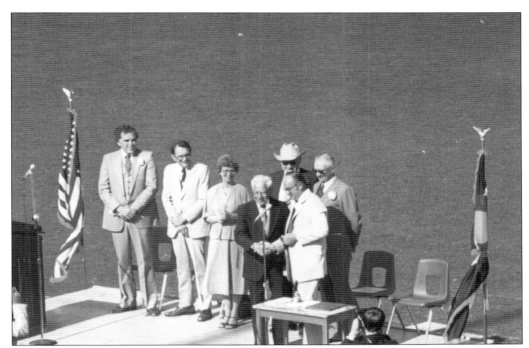

Dedication of Dudley Field, 1980. H. James Dudley served 34 years in Windsor schools, teaching junior high math and coaching boys' track and baseball. He served as an administrator for a few years but preferred teaching. In 1980, the high school stadium was named in his honor during the graduation ceremony. From left to right are Jack Hale, Harold Brokering, unidentified, Dudley, state legislator Allen Lamb, Reginald Figal, and Harold Simon. (John Dudley.)

Mayor Wayne Miller, 1940. After working as a veterinarian for 17 years, Miller served as Windsor's mayor for eight years. He was instrumental in expanding Windsor's public works. Miller notably championed Eastman Kodak coming to Windsor and prepared the town for the company's arrival. Miller is pictured here before attending veterinary school. (Windsor-Severance Historical Society.)

WINDSOR-SEVERANCE FIRE PROTECTION DISTRICT, C. 1950. The Windsor-Severance Fire Protection District was organized in 1950 to increase local fire protection and provide service to Windsor, Severance, and the surrounding farming districts. With a new siren and Ford rural fire truck, the Windsor department of the district moved into its new fire hall in 1964. Wives of the firemen, called "Firettes," organized in 1956 to provide the men with coffee and meals and hold bake sales to raise money for equipment. (Windsor Fire Museum.)

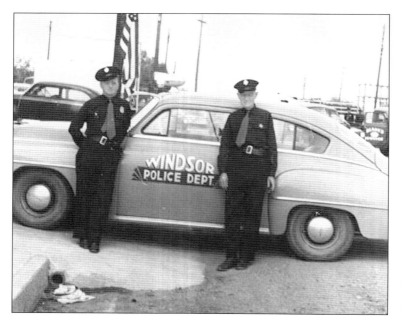

WINDSOR POLICE OFFICERS, 1952. Beginning as a small outfit, the Windsor Police Department initially included a day marshal, night marshal, and magistrate and later expanded to include a chief, a lieutenant, and several officers. Pictured here are officers Ed Heinze (left) and Jeff Allen. A night marshal for 16 years, Allen was a Windsor institution, making night rounds with his police dog, Nero. (TWM.)

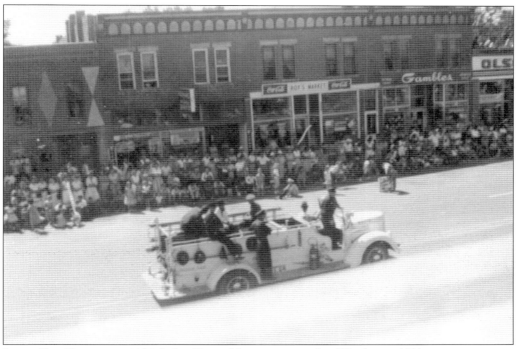

LABOR DAY PARADE, C. 1950. Labor Day celebrations started in Windsor in 1921 to commemorate the town's distinction as the first town in Weld County with a paved main street. Main Street served as the annual right-of-way for the Labor Day parade and carnival, which included various town groups and clubs, floats, and bands. (Windsor Fire Museum.)

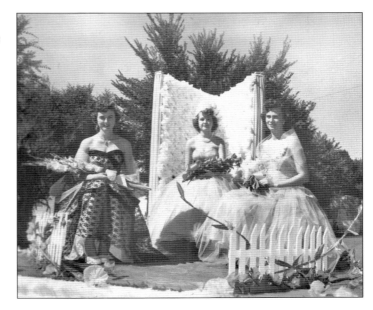

DUCHESS OF WINDSOR, 1954. After suspending the celebration during World War II, the town revived the Labor Day Carnival as the Harvest Festival. The election of the Duchess of Windsor was added to the festivities. Votes to choose the duchess were sold to Windsorites, helping to fund the festival. The 1954 Duchess of Windsor candidates pictured here from left to right are Betty Yost, Norma (Altergott) Ehrlich, and Cora (Brinkman) Behrens. (Windsor-Severance Historical Society.)

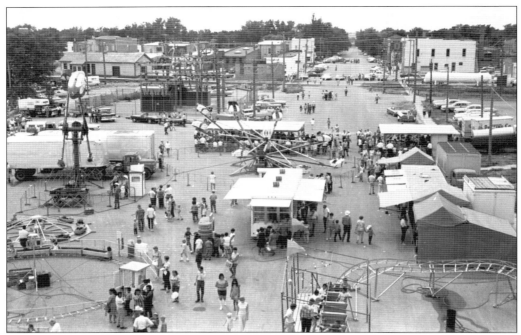

WINDSOR HARVEST FESTIVAL, 1968. Originally held along State Highway 392, the town moved the Harvest Festival to Boardwalk Park, near Windsor Lake, in 1959. Into the 1980s, the festival included carnival rides, parades, skydiving, tractor pulls, dances, art and flower shows, concessions, horseshoe and water-skiing tournaments, as well as other competitive games and races. In 1968, the Windsor Harvest Queen pageant became part of the celebration. The senior girl selected as the queen presided over the Harvest Festival activities. Above, the 1968 Harvest Festival featured carnival rides, while below, the Windsor Harvest Queen rode on her parade float. The parade made sure to welcome Eastman Kodak that year. (Both, Fort Collins Local History Archive.)

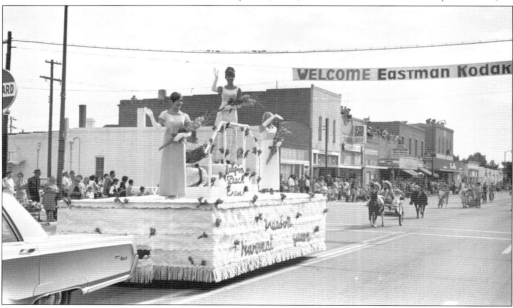

Seven
NEW INDUSTRY
KODAK COLORADO DIVISION

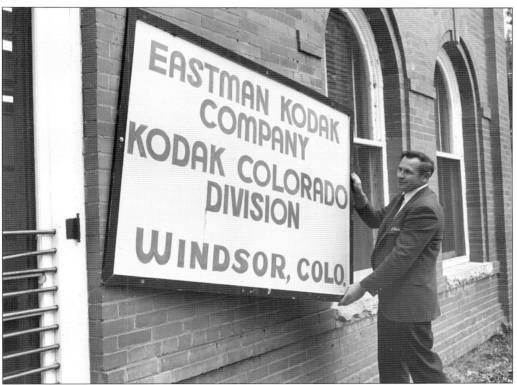

KODAK COMES TO WINDSOR, 1968. In 1965, after Windsor was bypassed by the creation of Interstate 25 to the west, which connected US Highway 34 and State Highway 68 (Harmony Road), it was no longer a "town between" but a "town out of the way," leading Windsor into further decline. However, the town rose again when new industry chose Windsor as its home—much like the sugar factory 60 years earlier. After three years of searching for a suitable location for a new manufacturing facility, on June 27, 1968, the Eastman Kodak Corporation, the world's largest manufacturer of cameras and photographic supplies, announced Windsor as the home of its future facility. Like the sugar factory, Kodak radically changed the landscape of Windsor, leading to a growth in population and drastic renovation and expansion of the town. Here, Leon Gebhardt from the security department hangs a sign to designate the old sugar factory as Kodak Colorado Division. (Kodak Colorado Division.)

REINVENTING THE SUGAR FACTORY, 1968. Several factors drew Kodak Colorado Division to Windsor, including its western location, dry climate, proximity to transportation routes, and labor supply. One of the largest benefits, however, was the 2,400 available acres left behind by Great Western. Taking possession of the former sugar factory and surrounding land, Kodak recycled the sugar factory building into its first administration building, moving in September 1968. (Kodak Colorado Division.)

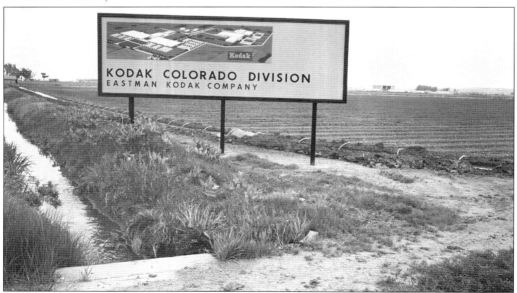

FUTURE CAMPUS, 1970. In the early 1960s, Kodak management realized that the company would have to double its manufacturing capabilities for films and papers by 1990 to meet future consumer demand. With its original plant in Rochester, New York, Kodak planned to build a massive manufacturing facility on its new Windsor property. The sign west of the undeveloped acreage depicted the company's plans for the future facility. (Kodak Colorado Division.)

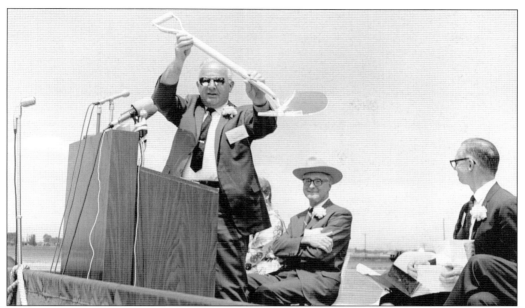

GROUND BREAKING, MAY 1969. The ground-breaking ceremony for the new Kodak Colorado Division turned out to be one of the largest social events in Windsor's history. Howard Smith, the first plant manager, holds the ceremonial shovel that was plated with Colorado silver, a symbolic metal essential in the making of Kodak film. Seated behind Smith are Dr. Louis K. Eilers, president of Eastman Kodak (left), and Dwight Neill (right). (Kodak Colorado Division.)

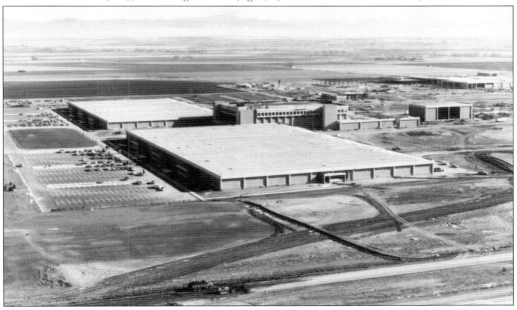

THE FINISHING COMPLEX, 1970. After the ground breaking, construction of the facilities began in phases and continued into the mid-1970s. Some of the first buildings constructed included the Finishing Complex: Buildings C11, C13, and C16. Rounding out the first phase of construction, the 435,000-square-foot distribution center, C20, processed incoming raw materials and shipped outgoing finished products to eight regional distribution centers. (Kodak Colorado Division.)

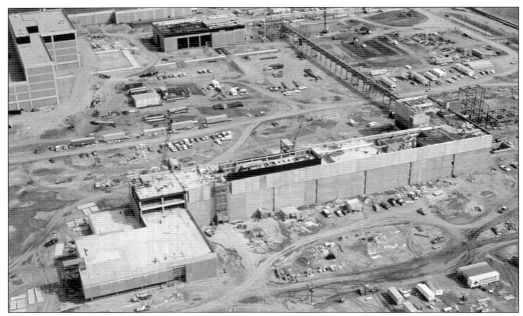

SUPPORT AND SENSITIZING COMPLEX, 1974. The construction of the support and sensitizing complex, C50 and C42, enabled the Kodak Colorado Division to manufacture photographic film from start to finish. In the support manufacturing building, seen in the foreground, employees manufactured flexible support material for film, also called base. Employees in the sensitizing building coated the film base with light-sensitive, image-forming compounds, the final step in manufacturing film. (Kodak Colorado Division.)

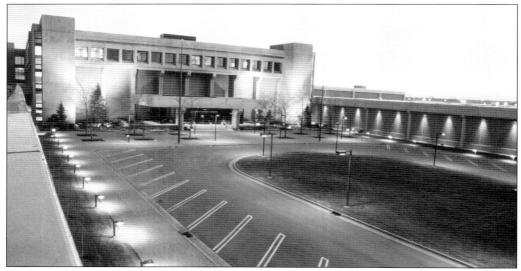

THE NEW WINDSOR EMPLOYER, C. 1978. Like the Great Western Sugar Factory before it, Kodak Colorado Division fulfilled its place as Windsor's single largest employer. By 1980, eight major buildings and numerous ancillary structures spread over 650 acres employed nearly 3,000 people. Around 85 percent of the workforce had been hired locally, while around 460 employees lived within the Windsor community. Building C11 (pictured) served as the administration building. (Kodak Colorado Division.)

KODAK EMULSIONS AND FILM, 1971. The initial five years of operation limited Kodak Colorado Division to final-stage manufacturing, called finishing. With the expansion of the site, the Colorado plant manufactured lithographic plates from start to finish, 16 mm and 35 mm motion picture film, phototypesetting paper, and nearly all of the company's medical X-ray film. By 1976, Kodak Colorado Division exceeded its operational goals a year earlier than expected. (Kodak Colorado Division.)

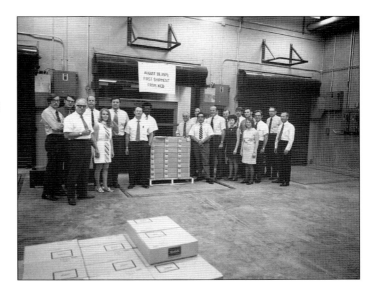

FIRST FINISHED PRODUCT, 1971. The first completed product at the Kodak Colorado Division, a roll of phototypesetting paper, came off the manufacturing line on August 10, 1971. Eight days later, Kodak prepared its first shipment. The company celebrated the occasion with a ceremony attended by Colorado governor John A. Love, management from Rochester, employees from Colorado, and a cake that read, "The First of Many!" (Kodak Colorado Division.)

KODAK WASTE TREATMENT PLANT, C. 1970. Working cooperatively with Windsor, Kodak Colorado Division constructed a large waste treatment plant to be used by the company and the town. The company paid one-third of the operating costs of the plant each year. (Kodak Colorado Division.)

TOURING THE PLANT, 1976. After constructing the initial phase of buildings, Kodak invited visitors to tour the newly constructed plant. Windsor residents, school groups, and vacationers arrived in buses before meeting in the lobby of Building C11 and touring the darkrooms and finishing complex where Kodak packaged the film. A guided driving tour took visitors through the plant and explained what went on in each building. (Kodak Colorado Division.)

INDUSTRY AND AGRICULTURE, C. 1975. The marriage of industry and agriculture continued with the arrival of the Kodak Colorado Division. Though agriculture is not part of the manufacturing of film, Kodak realized the importance of agriculture to the community and leased 1,800 of its 2,400 acres to farmers and ranchers for raising crops and livestock. Above, sheep graze around the site. Below, a farmer prepares the field west of the Sensitizing Complex. (Kodak Colorado Division.)

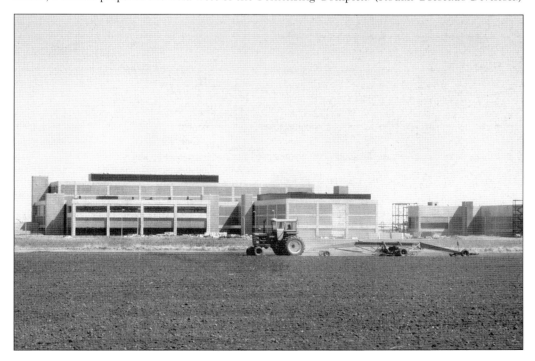

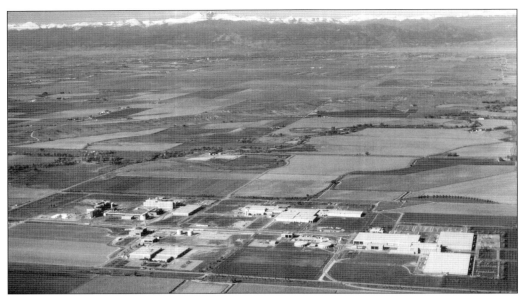

LOOKING WEST OVER KODAK AND WINDSOR, C. 1978. Although Kodak Colorado Division became more of a regional company than a Windsor company, the plant greatly affected Windsor and its future. Kodak employed many locals, paid a large percentage of school taxes, donated substantial funds and land to the town, and revitalized businesses. As Windsor resident Marj Kadlub remarked, "When it comes to being a good neighbor, [Kodak] got the picture." (Kodak Colorado Division.)

LOOKING BACK, 1980. In 1980, Windsor took part in celebrating Kodak's 100th anniversary; a hot-air balloon is pictured in front of the main complex. Though Windsor did not grow as rapidly as many thought it would with the arrival of Kodak, the town assuredly grew. In 1990, its centennial, Windsor remained a town between large cities, industry, and agriculture, but it was always at the center of community. (Kodak Colorado Division.)

Bibliography

Ford, Peggy A. "The History of Greeley, Colorado: History Distilled, The Greeley Story, 1870–2002." Greeley, CO: City of Greeley Museums Division.

Hamilton, Candy. *Footprints in the Sugar: A History of the Great Western Sugar Company*: Hamilton Bates Publishers, 2009.

Lindblad, Mary Alice. *A Walk Through Windsor, 1940–1980*. Windsor, CO: Self-published, 1980.

———. *Tails of Tailholt: The Story of Severance*. Windsor, CO: Self-published, 1985.

Morgan, Gary. *Sugar Tramp: Colorado's Great Western Railway*. Fort Collins, CO: Centennial Publications, 1975.

Ray, Roy. *Highlights in the History of Windsor, Colorado: Golden Jubilee Edition*. Windsor, CO: Press of the Poudre Valley, 1940.

Stone, Wilbur Fisk, ed. *History of Colorado*. Chicago: S.J. Clarke Publishing Company, 1918.

Thomas, Adam. "The Struggle for Identity: Windsor's Historic Downtown." Denver, CO: Historitecture, LLC, 2010.

Discover Thousands of Local History Books Featuring Millions of Vintage Images

Arcadia Publishing, the leading local history publisher in the United States, is committed to making history accessible and meaningful through publishing books that celebrate and preserve the heritage of America's people and places.

Find more books like this at
www.arcadiapublishing.com

Search for your hometown history, your old stomping grounds, and even your favorite sports team.

Consistent with our mission to preserve history on a local level, this book was printed in South Carolina on American-made paper and manufactured entirely in the United States. Products carrying the accredited Forest Stewardship Council (FSC) label are printed on 100 percent FSC-certified paper.